The

Higher Level Method

The

Higher
Level
Method

Success Stories on How to Master
Your Business and Life Goals

DARLENE WILLIAMS

publish
yⓐur gift

THE HIGHER LEVEL METHOD
Copyright © 2021 Darlene Williams
All rights reserved.

Published by Publish Your Gift®
An imprint of Purposely Created Publishing Group, LLC

Unless otherwise indicated, scripture quotations are from the Holy Bible, King James Version. All rights reserved.

Scriptures marked TLB are taken from The Living Bible copyright © 1971 by Tyndale House Foundation. Used by permission of Tyndale House Publishers Inc., Carol Stream, Illinois 60188.

Printed in the United States of America

ISBN: 978-1-64484-363-5 (print)
ISBN: 978-1-64484-364-2 (ebook)

Special discounts are available on bulk quantity purchases by book clubs, associations and special interest groups. For details email: sales@publishyourgift.com or call (888) 949-6228.
For information log on to www.PublishYourGift.com

This book is dedicated to all of the higher level thinking professional women in the works.

Do not give up!

TABLE OF CONTENTS

ACKNOWLEDGMENTS

I am beyond grateful to be afforded the opportunity to do the work that God has called me to do—empower others to live their lives out loud without trepidation. I am thankful to God for placing people in my life who assist me with my work.

Thank you to my amazing husband, Maurice, who goes above and beyond to make sure that I am able to operate within my calling. Words cannot express how thankful I am for your continuous love and support.

Thank you to Tie, Shani, Ty, and the entire Publish Your Gift team for their extreme level of professionalism, guidance, sense of humor, support, and patience.

Thank you to my son, Malik, for always pushing me to greater levels (sometimes without even knowing it). Thank you to my daughter-in-love, Rachel, for being a ray of sunshine.

Thank you to my coauthors: Ashley, Charise, Jennifer D., Jennifer A., Sheryl, Cassandra, Dr. Alvarado, Regina, Deidre, Michaela, Tameko, Krystal, Latasha, and Dr. Hicks for believing in my vision and supporting it fully. A special shout out to coauthors Fatima and Taniella for

also serving as sounding boards for those times when the stress became just a wee bit too much.

Thank you to my amazing friend, Kacy Duke, for her love, support, and random inspirational text messages that, unbeknownst to her, always come right in the nick of time . . . talk about divine intervention. God is REAL!

FOREWORD

As a lifelong fitness and wellness professional, I know and believe in the incredible power of women. Our wisdom, strength, intuition, and perspective are among the precious gifts we bring to the world each day. These gifts are made even more powerful when shared. So, when Darlene told me about this remarkable personal development "bible" she was creating and asked me to introduce it, I was honored to celebrate both her and the knowledge, wisdom, and experience she would share through these pages. It seemed only fitting that right now, in these unprecedented times, Darlene would gift us all with access to not only her decades of business wisdom and brilliant spirit, but also to that of her wise and wondrous colleagues who are coming together in this book, *The Higher Level Method,* to share their most profound lessons.

Years ago, long before I'd even met her, I had an ally in Darlene. Though I didn't know it at the time, she was my behind-the-scenes champion—following my career, cheering me on from a distance, and celebrating my accomplishments as wins for all women. Nobody was more delighted to see me on the covers of magazines which had for so long ignored the power and beauty of women of color.

As proud as I was to break through the barriers and be featured in legendary magazines like *Essence*, *Elle*, *Vogue*, *New York Magazine* as well as on TV, I was truly humbled when Darlene later shared that my presence on those covers had inspired her. What she didn't know at the time was that all the while she had been an inspiration to me too. I knew and admired her reputation and work as a top image-maker and personal development professional who was out there every day breaking the rules, making new ones, uplifting all, and leading the way. Though we ran in different circles, we were very much kindred spirits.

After following each other's careers for years, when at last we did finally meet, our spiritual connection was immediate; but, it was our mutual desire to empower and inspire others that sealed the deal. That shared mission is the stuff of which great friendships are made and it's the beautiful, ever-evolving foundation upon which our sisterhood is built. It's also the cornerstone of this book—the idea that we all can learn from each other and pass our professional and personal life lessons on to young women to help them aspire to reach their goals and achieve their dreams. Though many of the women featured in this book had to design their own paths, often without roadmaps or mentors to guide them, readers of this book, thanks to Darlene, won't be on that road alone. They'll be ready for anything—armed with the wisdom of those who have gone before.

If only I'd had this wise sisterhood in my corner back when I was starting out! Though I wouldn't change the

past, I have learned from all of it, both the good and the bad. If I had the chance to speak to my younger self, I'd share with her a few of the same truths I now share with my celebrity and non-celebrity clients, particularly when they're trying to work through their own physical or emotional challenges. First up, always remember to stay connected to your intuition. As I've come to learn (sometimes the hard way!), that's the voice of the Higher Power speaking to you. Listen to it deeply; ignore it at your peril! When something doesn't feel right—be it a situation, a person, or a decision—don't second-guess yourself. Trust yourself, trust the journey, and move on. Next, and I know Darlene would agree, remember that life is yin and yang. There are ups and downs, ebbs and flows, highs and lows. Without one, you can't fully appreciate the other, so be ready to welcome the waves and ride 'em! When things get rough, remember that troubles aren't forever. Calmer waters will return, even if it takes a while. Lastly, view every challenge as an adventure or an opportunity and you'll never lose. Oh, and another thing: live life like it's golden, because it absolutely is.

You know what else is golden? Darlene's heart and mind, which you'll also see in these pages. To me, there's no one better to provide advice for young women making their way in the world. She's the wise big sister we all wish we had, the cheerleader we all need, and the smart cookie who connects us with the wisdom each of us needs to thrive. Think of *The Higher Level Method* as the greatest dinner party you'll ever attend with fabulous

guests and conversation, plus plenty of "food" to nour-ish your soul for years to come. My advice? Listen up and dig in!

Kacy Duke, Celebrity Fitness Expert
AgeDefyingPhysique.com
IG and Twitter: @kacyduke
Author of *The Show It Love Workout: A 3-Step Plan for a Stronger, Leaner You*

INTRODUCTION

D. Aiken & Associates Worldwide is the preeminent personal and professional development coaching firm that grew to become such through trial and error. It was birthed into existence by way of the many ideas, hobbies, community service projects, and companies that preceded it. It also came into being by way of much rejection, disappointment, lost affiliations, and so on. Regardless, in order to still stand, one must endure the storms and pitfalls, and there will be plenty. However, being relentless about my formula is what has made this firm possess staying power. The success formula: **Higher Level Thinking + Higher Level Performance = Higher Level Results. Period!** ™

Success is something that many people desire and strive to attain. **The Higher Level Method** ™ will provide you with a wealth of knowledge that will assist with your professional alpinism. Each chapter is uniquely crafted by seasoned professional women from across America, providing you with precious gems that consist of advice that will elicit a positive change while on your journey, all while erupting contemplation about how you maneuver.

STOP! Please take a moment to ponder each of these questions: Do you actually consider the true purpose of

success on a regular basis? Have you thought about what your end game will look like? Will success prevent us from dying? Can success prevent you from aging? Has success helped you love people more or less? Will success help you create balance or division? Success means something different to each of us. **The Higher Level Method** ™ cannot tell you what to deem as success. But if success is your goal, this book will provide you with the necessary tools to achieve that goal. Once you procure the tools, you will still need to do the work.

Achieving true success is NOT easy! It is a lot of hard work, determination, rejection, doubt, and fear. However, once you've had a true taste of success, you will then appreciate the arduous journey. This is why successful people protect their success and are strategic about having other successful people in their immediate coterie. You know the popular cliché: "Birds of a feather flock together."

The Higher Level Method ™ will challenge you to reflect on your past habits while cultivating new patterns of behavior that will assist in your climb. Hint number one: higher level living is not solely about material acquisition. Things are merely the proverbial icing on the cake. To find out what higher level living and thinking *REALLY* consists of, I implore you to read and reflect on each of the forthcoming chapters.

Chapter One
YOU CAN BE A MESS AND A SUCCESS
Ashley Sides Johnson

Transforming complex topics into understandable stories and instructions is Ashley's superpower. She has spent 14 years honing this craft as a healthcare communication specialist and more recently as a professor, author, and advocate for improving mental health in the workplace.

In her book, There's an Elephant in Your Office, and TEDx talk by the same name, Ashley visualizes employees with a mental health disorder as one of three kinds of elephants. This metaphor helps people recognize and better support their coworkers who experience poor mental health and enables everyone (including the business) to succeed.

Ashley shares the importance of addressing mental health on her podcast. She also speaks at conferences and provides training to groups across the country.

Ashley received her undergraduate degree from Centre College in Kentucky and her master's degree from Western Kentucky University. She teaches public speaking at the University of Southern Indiana and is a certified youth mental health first aider.

Learn more at www.elephantinyouroffice.com

It took an entire week and three panic attacks to write the author bio for this book. My author bio. Literally a

paragraph about me and the amazing work I get to do. Why was it so hard? Because eight million thoughts of self-doubt crept into my mind while writing and dismantling each thought takes a ton of time and energy. But I did it. I can do hard things.

It may take a little longer and look differently than how other people do it, but I can do hard things.

Right now, I'm laughing at myself because the journey to find and accept that simple affirmation took about ten years and thousands of dollars in therapy. You see, I live with mental illness—generalized anxiety disorder (GAD), accompanied by seasonal affective disorder (SAD), and the occasional anxiety-induced episode of major depression to be exact—and it significantly impacts my daily life.

I know publicly acknowledging my disorder may not seem like a big confession or a serious hurdle to success, but I assure you, it is. For me, it's the equivalent of unleashing the monster of judgment, insecurity, and fear. It's admitting defeat. It's saying to the entire world that I am less than perfect and broken in so many ways.

Now, if disclosing my mental health conditions is so terrifying, why would I voluntarily print the details for everyone to read? Because I need you to know that you're not alone. You are not the only person who struggles with their thoughts, feelings, and emotions. I'm writing to tell you that lots of successful women manage a career, personal life, and mental health disorder.

In fact, the National Alliance on Mental Illness (NAMI) reports that one in five US adults will experience

mental illness in a given year. That's roughly 44 million people! And guess what . . . those are pre-coronavirus numbers. Experts won't know the true extent of how many people suffered poor mental health due to the pandemic, and 2020 in general, for quite some time. But if the preliminary statistics from Mental Health America are any indication, I'll be welcoming a lot more people to the "I live with a mental health disorder" club.

Are you one of them? Maybe this is the first time you've experienced depression, disordered eating, or crippling anxiety. Maybe you're all too familiar with this ride. Either way, if you are one of the millions of US adults that experience mental illness, it's important to maintain positive momentum in your personal and professional life. But how can you keep moving toward success while managing your condition? You need a plan. Not sure where to start? Try this.

A Three-Step Path to Success:
- Get control of Barbara
- Put on your perspectacles
- Make wellness a priority

GET CONTROL OF BARBARA

First of all, who is Barbara and why does she need to be controlled? Well, Barbara is the voice in my head that tells me how worthless I am and that nothing I do will ever work. She's a hateful, angry, loathsome, scaredy-cat that bosses me around. When I listen to Barbara, I forget that I do good work and that I'm smart and capable. When Barbara rules my thoughts, I become the most

useless waste of space. I could win a Nobel Prize and still think it wasn't good enough.

I bet many of you have a "Barbara" in your head even if she doesn't have an official name.

(To be clear, this voice is my internal monologue, the totally normal thoughts that pass through everyone's head as they navigate life. It is not the product of schizophrenia.)

My inner voice didn't have a name either until this year when my therapist explained a new-to-me coping mechanism. During a bout of depression and serious frustration, she told me to name my disorder. Give my anxiety and depression an actual person's name because assigning a specific identity to my self-talk voice would help me separate the negative, accusatory, self-defeating voices from my real self. Making the disorder someone totally separate would allow me to push back against my interrupting thoughts and regain control.

This tool gave me power over my illness. It allowed me to fight back without damaging my self-worth. I can tell Barbara to shove it, or shut up, or a lot of other things not appropriate to publish, without adversely affecting my confidence or self-esteem. It's really been a game changer for me, and I highly recommend it to anyone who battles negative self-talk.

Pro-tip: Before you decide on a name, practice screaming it from your door, house, or yard. For maximum results, it needs to be easy to yell.

PUT ON YOUR PERSPECTACLES

Perspectacles : noun; combination of perspective and spectacles; imaginary spectacles or glasses that give you perspective on a situation.

Years ago, a few colleagues and I started using perspectacles in our work projects. I think we invented the word and to us it meant "reality check" or "take a minute to consider the entire picture" or "it could be so much worse."

Personally, the concept of perspectacles helps me separate truth from what I think. It gives me perspective on my projects or accomplishments and works in tandem with my "Barbara" strategy. I depend on this self-help technique for motivation. Without it, I would be convinced that I am a complete failure who has never accomplished anything of value.

To better illustrate the concept, here's a recap of a therapy session from earlier this year:

Me: "I really enjoy teaching, writing, and giving presentations but there's just no way I can make a living doing that stuff. These other women have such successful careers. They get invited to speak at big events and people really love what they have to say."

Therapist: "Who published their first book last year?"

Me: "I did."

Therapist: "Who gave a one-hour workshop on mental health in the workplace for a top-100 company?"

Me: "I did."

Therapist: "Who got on stage and delivered a TEDx talk a few months ago?"

Me: "I did, but I messed up in the second part and forgot a chunk of what I was going to say, and it was so awful."

Therapist: "Do you ever give yourself credit?"

Me: "Uh . . . I guess not."

Being successful and feeling successful are really two different things. I can create a 10-page resume and fill it with tons of amazing personal and professional accomplishments but still feel unworthy of the job. I can be selected to speak or give a presentation and have my material ready to go, except for the speaker's biography. There's really nothing to say about me. Just call me to the stage and move on with the program.

This inner conflict, the notion that I am not good enough, represents my biggest hurdle to success. Essentially, I can't be successful until I get out of my own way. But how do you do that? Perspectacles. Quiet the external noise and focus on you. What are your goals and dreams? At your core, what do you want to do?

For the majority of my career, I refused to wear my perspectacles, thus making the world one big, blurry blob. It literally took the worst, most embarrassing, awful, I still don't want to talk about it, episode at work to force those spectacles onto my face. The short version of a very long story goes like this: The year is 2017. I work as the senior corporate communication specialist for a health system. I speak on behalf of the company, work

with the media, and try to stay ahead of any potential public relations issues. I arrange ribbon-cuttings, open houses, and huge press conferences. I also spend a lot of time with the CEO because I draft her letters, speeches, award nominations, and internal communications. I am trusted with the most high-level information and yield a certain amount of power.

During this same time, a change in the insurance formulary caused my anti-anxiety medication to increase from $40 per month to $350 per month. That's almost a nine-time increase! Paying that much each month just for my medication would put a serious burden on my family and our finances. But I needed that medicine to function and hold a job. What was I supposed to do?

Thankfully, I already had an established mental health provider with medication management privileges. She and I reviewed my medical history and concluded that regardless of the price increase it really was time to change meds. Apparently, your body adapts to a drug after so many years and it becomes less effective. I had taken this particular anti-anxiety medication daily since the birth of my child about 11 years earlier so decreased effectiveness seemed plausible. And if I was being honest with myself, I knew that the medication wasn't working like it should. My mental health had been deteriorating for months.

In early 2017, I stopped taking my usual medicine and tried the first of many new drugs. The initial withdrawal symptoms left me confused, tired, and annoyed. The side effects of each new medication seemed worse

than the one before, and because it takes about four weeks for a new psychiatric medication to fully take effect, you don't know if something works for a long time.

By the end of summer, I was completely exhausted both mentally and physically. I really needed to take a leave of absence and get my head together. I would have benefitted from intensive outpatient therapy or maybe even an inpatient stay, but I neglected my own needs and soon faced the consequences.

You see, I still showed up to work but didn't really work. I couldn't concentrate, meet deadlines, or return phone calls. I was a complete mess. After a while, my manager noticed the drop in productivity and after several months of being on a performance plan and having to justify every single move I made at work, I was given the choice to move to a supplemental position or quit.

I chose the supplemental position and didn't work (or really leave the house at all) for about nine weeks.

During that time, I thought a lot. Who was I and what did I really want from life? Based only on my talents and abilities, how should I define success? What was my path forward?

While I waited for answers to magically appear, I wrote. It started with a couple of blog articles and quickly turned into writing a book. Along the way, a friend at an ad agency hired me to help create some marketing materials for a program at the local health department. The program supported pregnant women and taught them critical life skills. To this day, I am so proud of

what we created and will never forget how it felt to know my contribution made an impact on someone's life.

That experience reignited my desire to work. It reminded me that I had value and something to offer. It also helped me verbalize what I wanted from life and how I would find success. I'll save you the details of my soul searching and just tell you what I figured out:

- I want to do good work and help people.
- I will be successful when the things I write or say make a positive impact on someone.
- The way I experience success is unique and I can't compare my journey to anyone else's journey.

So easy, right? *facepalm*

MAKE WELLNESS A PRIORITY

I'm sure you've heard expressions about how you can't take care of other people unless you care for yourself first i.e., "You can't pour from an empty cup" or "Put on your oxygen mask before helping others." Well, they're true. All people need balance to stay healthy. Making conscious and intentional decisions about food, drinks, sleep, stress, and relaxation keeps your body's systems in check and operating at full capacity. For those who live with a mental health condition, self-care is essential if you plan on functioning in the world. But it goes way beyond a bubble bath or a massage. Self-care means doing what you need to do to stay healthy, even when it feels pointless.

Need an example? How about doing exercise videos in your bedroom during a bout of depression. You might cuss that instructor out for a solid 30 minutes and stay on the floor long after the core strengthening section is over, but you moved. You activated feel-good chemicals in your brain and that keeps you from sinking lower into depression.

A few other things I've learned, often the hard way, include:

- Get enough sleep—it really makes a difference in your mood
- Take your meds (as prescribed)
- Eat real food and not a bunch of junk (I love ice cream.)
- Attend therapy sessions as scheduled
- Engage with friends and family, even if you don't feel like it
- Tell someone you trust that you're having symptoms or a rough day
- Identify a cheerleader. Lean on them when you can't see through the doubt

Some days you will be on top of your self-care game and other days you won't have the strength to shower. It's okay. Take it one step at a time and focus on what you did accomplish. You brushed your teeth. Fantastic! You drank some water in between all the cups of coffee. That counts! You paid the rent or electric bill. You successfully adulted! You absolutely cannot get it together, so you go to bed and get up tomorrow to try again. Winner!

Whatever it looks like for you, make wellness a priority. You can't stream funny videos if your phone's at one percent.

Now that you know my three-step path to success and about my horrible year at work, there's really only one secret left to tell . . . I have no magic words or powers to make living with mental health disorders easier. In all honesty, I'm making it up as I go. I'm sharing pieces of my life through writing and speaking because someone has to. Someone has to talk about mental health in an open way and my sixth-grade teacher said I'd talk to a brick wall if I thought it would talk back. Use the gifts you're given, right?

So, with my invisible megaphone and best public speaking voice, here's my take-home message.

Having a period of poor mental health doesn't cancel out success, it simply obstructs it from view. During those times when you can't get it together and your symptoms overwhelm you, in those moments, extend yourself some grace. It's what you would do for others. Please believe you don't have to be perfect before you chase a dream. You can be a mess and a success at the same time. Trust me.

Chapter Two
EMBRACE BUSINESS BASICS
Taniella Jo Harrison, MBA

Taniella Jo Harrison, MBA, is a healthcare entrepreneur and patient experience expert. As co-founder of ACCESSFirst Homecare Services, she provides families with tailor-made private caregivers who meet the needs of seniors and people with disabilities. Taniella is also a NYC and Long Island entrepreneur who has been recognized in Forty Under 40 by *The Network Journal*. She has received the Fortune 52 Award from the *Long Island Press Newspaper* and the Women's History Pathfinder Award in Business from the Town of Hempstead.

Her background includes serving as the executive vice-president of one of the largest minority women-owned businesses on Long Island: Tri-County Home Nursing Services, and patient experience at NYC Health & Hospitals. Taniella earned her MBA at Nova Southeastern University and her BS in business administration from Tuskegee University. She also served as the vice-president of the National Coalition of 100 Black Women, Long Island; the vice-president and secretary of the New York State Association of Healthcare Providers, Long Island; and is a current board member of CABS Home Attendants in Brooklyn, New York.

Learn more at www.AccessFirstHomecare.com

Once upon a time, there was a girl who loved teddy bears, books, and being a part of the Girl Scouts. The little girl grew to have dreams of being an entrepreneur after seeing her grandmother, Ella Mae, start a business from scratch and become a successful business owner. All throughout high school, college, and graduate school, the young lady focused on learning business theories and methodologies to soon use in her own business endeavors. As I sit back and think about what I've learned thus far and pinpoint advice I'd give to that young lady so she's armed with serious ammunition to fight and win, I want to share this same advice with you. I would have liked to have avoided mistakes and heartache that only a hands-on business owner like myself has faced. There is no doubt I have learned and instituted many lessons into my new business endeavor, ACCESSFirst Homecare Services, Inc. I have compiled five foundational pieces of business advice I want to share with you.

1. **Continually make investments into innovation and improving quality**. In your approach to business, try new things, make mistakes, and recover quickly. Take the time to create a progressive continuous quality improvement method whether you are selling a product or a service.

2. **Intimately know your numbers**. Knowing and understanding are two different things when it comes to financial marks that will guide you and allow you to make good business decisions. The quality

of your decisions will affect your business success; therefore, it is best to be armed with the necessary financial tools.

3. **Create your own company culture that is endearing and embraced by employees**. Create a culture within your company around well-defined core values, principles, and purpose that breeds kindness, communication, sensitivity to differences, and being the best you can be.

4. **Set your company apart through a well-defined competitive advantage**. Create a branding strategy that identifies what you stand for and what makes your product or service different. It is imperative that you identify a strong case for why a prospective customer should buy from you. This case should always be reflective of fulfillment of the customer's needs.

5. **Create a customer experience that reflects your deep understanding and ultimate fascination of prospective and current clients**. This leads to creating an evolving customer profile aka buyer persona. This is the creation of a portfolio of deep insight and understanding into your perfect customer.

INNOVATION AND CONTINUOUS IMPROVEMENT

As a business owner, being able to keep up with new technology and working in an environment that allows for the testing of new ideas is crucial. Trying new things will surely cause you to experience failure. You must

have a healthy relationship with failure and mistakes to the point where you are excited about your mistakes and you focus on pulling out what you can use to make your operation better and meet your business goals.

Today, companies thrive in an environment that is highly competitive. Companies that have been popular in the past have closed and shuttered their doors for good. Businesses that were stable fixtures in our communities, like iconic department stores such as Sears, Lord & Taylor, J.Crew, Kodak, and the mom-and-pop bookstores are struggling and not able to stay in business through shifts in the economy and the global pandemic. Subsequently, these forces reflect how well a company decides to embrace new ways of doing business. Look at the rise of new innovative companies like Netflix and other streaming services, Uber, and most recently Zoom, Inc. These companies utilize technology and have been change agents in their industries. Some areas in which a business owner can achieve innovation are in product performance or improvement of features. For example, in my home healthcare company, we have a caregiving service that consists of AAA caregivers. Staff in this category have achieved what we have defined as "above and beyond" specialized training to meet the needs of our clients. Our AAA program allows the organization to have available caregivers that will support client's goals and compliment their needs and personalities. Innovate the process of how you make, produce, and deliver your product or service.

Cost savings were realized when my company changed technology from the industry standard to a new technology company that was more flexible and integrated many different functions under one platform. Another way innovation can be harnessed is through your business model. For example, the sprouting of Uber Eats, Postmates, Seamless, Instacart, and other popular food delivery services has totally changed how consumers receive their groceries and prepared meals from their favorite restaurants. As a business owner, you must cultivate a company culture that encourages and prioritizes innovation before it is too late to shift.

KNOW YOUR NUMBERS

Have you heard about the highly regarded accountant responsible for the financial records and books of a company that was found to have made a very costly mistake that the company paid for dearly? The business owners trusted that the accountant's interpretation of financial guidance was correct and signed off on whatever the accountant gave, listening to his explanation. If only the business owner had thoroughly, and I mean thoroughly, understood the numbers! This is a common story from many failed businesses throughout history.

I highly recommend utilizing a financial management software like QuickBooks to start out so that every transaction you make can be recorded and easily interfaced with your bookkeeper and accountant. Make sure you produce an operating budget and financial statements. According to Julie Bawden-Davis who

specializes in business finance and writes for American Express, there are seven financial numbers every business owner should know to help make sure that your business's bottom line stays out of the red.

(1) Cash flow. A key indicator of how healthy your business is operating. It includes depreciation adjusted to your net income and accounts for receivables and inventory. Adequate cash flow is measured by cash coming in through sales (revenue) that covers cash going out (expenses). This number represents a clear signal of how healthy you are running your business.

(2) Net income. What some may define as your company's net earnings, represents your overall total profits after you minus every expense. This is the cash you have available to use in your business. Investors comb stocks to find the companies with high net income ratios in which to plunge their money.

(3) Profit and Loss. This number is found at the end of your profit and loss statement which is one of the four essential financial statements most businesses generate on a regular basis—usually quarterly, every six months, or yearly.

(4) Sales. It is important to know your sales figures broken down by day, week, month, quarter, and year. You should compare these figures with your past performance and use the figures to forecast and budget for your future.

(5) Price point. Knowing how to correctly price your products and services is a key element to your overall business strategy. But price is not the only driver

of sales. You should take into consideration all expenses that contribute to placing the product into your customer's hands. Research pricing strategies for your product or service and make sure your strategy factors in your competitors' prices for similar product offerings. Awareness of the connection between quality and price is key.

(6) Gross margin is important because this number represents the percentage of your sales you will need to cover fixed costs like rent, insurance, and other operational expenses. After these expenses are covered, the money remaining represents your profit that can be used to innovate and expand your business through marketing, research, and development.

(7) Total inventory (if you are selling a product). When you purchase raw materials to make your products and inventory bought at a wholesale price, your intention is to sell it and eventually make a profit. You can deduct the expenses from buying, altering, and selling your inventory from your business taxes, reducing your overall tax liability. Plus, you can use the asset value of your inventory to qualify for a business loan if needed.

In my professional experience, I must add the following to Julie's list of *seven numbers to know about your business*:

- **Break-even analysis:** This is ultimately a sink or swim number and the analysis is imperative to your business's survival. When your business is breaking even, that means that your income is equal to your costs. This is the point you must get past to find your profitability. Utilize a break-even

analysis when formulating your pricing strategy for new products and services.

- **Per unit cost:** Unit cost is another crucial number to be aware of as you operate your business. The unit cost is one of the most underrated and most important tools available because it looks at all of the resources you have put into providing the product or service.

- **Productivity values:** You should tabulate how many minutes, hours, or days it takes you to produce your product or provide your service. How many customers are acquired per dollar you are spending on social media marketing? For example, what is the timing from when you first receive the request for service or a product purchase is made to the point when the customer receives the service or product?

- **Customer experience measures:** Plan to incorporate customer satisfaction surveys. You can use the survey results alongside other important metrics such as: trending complaints, service callbacks, repeat orders, referrals, compliments, and returned products. For example, what are the reasons customers that shopped your store returned items in the last month? Track the reasons like defective merchandise, wrong size, color, etc. This will allow your organization to keep the pulse of problems and product or service design needs and changes.

CREATE A CULT-LIKE CULTURE

"A cult?" you say, "That sounds strange, weird, and downright evil!" Not exactly. In his book, *Built to Last: Successful Habits of Visionary Companies*, Jim Collins coined the phrase, "Create a cult-like culture" which is as true today as it was over 25 years ago when the book was written. We look at the success of companies like Nordstrom, Amazon, and Zappos. In his writing, Mr. Collins outlines how only the best of the best companies know how to go beyond the written words of a corporate purpose, mission statement, general principles, and goals. These exceptional companies have mastered creation of an environment that includes internal language and actions that strengthen corporate values and influence the perceived brand. One of my core success strategies is to infuse the corporate stances into my employees by using special language throughout communications. For example, a core value of my company is: "We are all different and have come together in this business for a reason. Keep in mind that no one person is perfect and that we must highlight employees' strengths and diminish the effects of their weaknesses on the business operations." A quote from the president of a company where I was handpicked to be the executive director is, "We are here for our strengths, not our weaknesses!" What that meant to me as a leader was that it was my duty to know and understand each individual employee, consultant, and outside contractor to identify exactly where people should work within the organization. I quickly learned that my opinion or insight alone is not enough and that

I must rely on managers, coworkers, and customers' insights as well as individuals' strengths. Minimizing weaknesses is also imperative. You can only isolate the strengths and weaknesses of each employee and utilize the insight if you have created a corporate culture predicated on honesty and integrity. Openness is key because employees should have a "winning team" mentality.

COMPETITIVE ADVANTAGE

Knowing your competitive advantage is important in order to articulate it to potential investors. It is also an integral aspect of your elevator pitch. As a business owner, it helps you to form the groundwork of your business strategy and should answer the question of "why" you are in business. Staying on the cutting edge through differentiation in how you offer your product or service is key. Competitive advantage through quality, innovation, price (whether it is a higher or lower price), or other specific business actions such as finding lower fixed and variable expenses will set your company apart from your competitors. Sujan Patel, the co-founder of Web Profits and a FreshBooks Blog contributor makes the point in his article, "Nine Strategies to Gain a Competitive Edge," that "86 percent of consumers are checking out your competition for at least half of their purchases. How does your company stack up?" In my company, we were among the first to utilize technology in ways that long-standing companies who were our direct competitors had not; thus, a spotlight shined on our brand allowing the business to gain market share.

CUSTOMER FASCINATION (CUSTOMER EXPERIENCE)

Be strategic in how you spend money on marketing for your business by digging deep into your prime choice customer's behavior. You must be fascinated by and utterly in tune with your customer to the point where you know what type of pajamas they sleep in and exactly how they like their coffee or tea in the morning. Does your customer call his wife to discuss product specifications before making certain types of purchases or does your customer shop online for certain items? My team created a specialized two-month home care service offering for mother's post-delivery. This service was a hit, increasing revenue by 15 percent. Our project manager designed marketing activity targeting doulas and birthing centers in a targeted geographic area that consisted of consumers that lived in homes valued between $750,000 and $2 million. You must utilize a customer-centric product design strategy and employ the right marketing techniques to get my target audience's attention. You may create several different buyer personas consisting of your "most likely buyers" that reflect different market segments. You gain this type of customer insight by dividing your customer base into segments based upon shared characteristics such as common interests and needs, lifestyles, and demographic profiles.

In conclusion, I would not have changed a thing. The difficulties I have experienced running my own business inspire me to find creative solutions to problems and continually improve the way I do business. A

business owner must recognize and acknowledge that there are some universal basic concepts available to entrepreneurs to utilize across any industry. Do not ignore the resources available at the Small Business Administration and through your local and state governments' initiatives. Most importantly, once you have operated your business for a few years and have filed the proper tax returns and have financial statements, make sure you contact the general office in your city for minority and women business owners and become certified through the official process. This will allow your business to be listed among those in your state and enable you to take advantage of opportunities to subcontract with government entities and other organizations who may want to select a minority or woman-owned business as a partner. Go for it and keep improving your business offerings until you see your vision happen!

Chapter Three
BUILDING YOUR BLOCKS
OF CONFIDENCE
Fatima Y. Robinson

~~~~~~~~~~~~~~~~~~~~~~~~~~~~~~~~~~~~~~~~~~~~~~~~~~~~~~~~~~~

Fatima Y. Robinson was born in Brooklyn, New York, and raised in Wilmington, North Carolina. She currently lives in Suffolk County, New York, with her husband, Dennis, and her two children, LaQuan and Deniya. Fatima graduated from Iona College with a bachelor of arts in criminal justice and received a master of arts in criminal justice from John Jay College of Criminal Justice. Since 2000, Fatima has been an advocate for New York City's children and youth's safety and well-being. Fatima loves to serve her community by volunteering in soup kitchens, making donations to homeless shelters, and sharing the love of basketball through youth sports along with her husband and children. Fatima is an active supporter of AIDS Walk NY (AWNY) and breast cancer research; she promotes awareness and provides monetary donations to fund research initiatives. Fatima enjoys spending time with her family, close friends, and sorority sisters.

To connect, email her at F7775R@aol.com

~~~~~~~~~~~~~~~~~~~~~~~~~~~~~~~~~~~~~~~~~~~~~~~~~~~~~~~~~~~

Build your own blocks of confidence! Never expect anyone to give you anything. Never expect someone to request something on your behalf. If you sit around and

wait for others to give you something, it will be delayed or you will never receive it.

As I think back to my childhood, I remember sitting in church, smiling from ear to ear, swaying from side to side, and clapping my hands as I listened to the children's gospel choir. After church, during our walk home, I remember asking my grandmother if she would sign me up to join the children's choir. As she turned to me, I immediately stopped in my tracks. She said, "If you want to be in that choir, you will go and sign yourself up." I took her response as a no, although she never once said the actual word. We continued our walk home and I stopped thinking about joining the children's choir, until the following month on the third Sunday. I was excited to go to church on the third Sunday because my favorite choir, the one I wanted to belong to, was singing. There I was, once again, swaying side to side, snapping my fingers, clapping my hands, and enjoying the sound of the children's choir while wishing I was in it. That day, I felt I had another chance to ask my grandmother if she would sign me up for the children's choir.

"Grandma, pppllleeeaasssee sign me up." While saying those words, I put my hands together like I was praying. I was pleading with her in hopes that she would immediately whisk me over to the choir director and sign me up. Nope, the begging and pleading didn't work. Once again, my grandmother responded, "I told you before. If you want to join the choir, you will go on over there and sign yourself up." My grandmother pointed in the choir director's direction and said, "Go on ahead.

There goes the director. Go sign up." I didn't move; I was afraid and didn't understand why my grandmother refused to sign me up. My grandmother looked at me sternly and incessantly asked, "Are you going?" I looked at her and shook my head no. My grandmother then replied, "O k, so let's go home." Of course, I was once again upset that my grandmother refused to sign me up for the children's choir. After that moment, I never brought it up again. If action by me was required, I would have to let my desire to join the choir dissipate, despite my longing to be singing in the pulpit on the third Sunday of the month.

Later in life, I realized that I never joined the children's choir due to FEAR. Instantly, a blackboard appeared that I did not see as a child, and I realized my grandmother instilled a lifelong lesson in me. She was teaching me, from the very beginning, that if you want something, you must be proactive and go after it. And if you do not go after it, then you didn't want it. That experience taught me to go after my dreams, desires, and everything that I wanted to achieve in life. It was a lesson about courage, confidence, speaking up, and not allowing others or fear to prevent me from seeking what I desired in this world that owed me nothing. After that experience, I knew my grandmother expected me to use the tools she gave me to take the initiative and go after what I wanted. So, when the time came around for Pop Warner cheerleading, I knew that I had to seize the opportunity and sign myself up. NO FEAR. I remember confidently walking to the community center, signing

up for the cheerleading team, and trying out for the Eagles. There was one problem. I did not meet the age requirement to be on the team. I was five at the time. Once again, I was upset. After all, I was being denied something I desired because I was five, and there was nothing I or my grandmother (if I dared to ask) could change to get me on the team. I remained hopeful, waited, and when I turned six, I walked confidently back to the community center. I signed myself up again, tried out for the cheerleading team, and successfully became a cheerleader for the Pop Warner Eagles.

From a very young age, my grandmother infused confidence, strength, courage, and determination into me. As an adult, I now understand that my grandmother was preparing me for a world where I would meet obstacles, and she gave me the tools to direct my own personal and professional growth.

About two years ago, I was faced with a situation that challenged my character, integrity, and professional skills. I had to walk confidently and armor myself with the courage, determination, and strength built within me by my grandmother. A promotional opportunity became available in my professional industry for which I was the most suitable candidate. As the director of the newly developed program, it was inevitable that I would be considered for the executive director position. As fate would have it, there was another plan, and I would have to use every attribute to "go on ahead" instilled in me by my grandmother to not surrender to the red flags meant to stop me. During a planning meeting to discuss

the future leadership of the program, the leading executive indicated that the agency wanted to go in another direction and the better suited candidate for executive director would most likely possess the skills that in my eyes would set the program on the path of failure, not success. As I sat in the meeting, along with other co-workers, in the distance I saw the onset of several red flags waving in the air.

Red flag #1. The preferred candidate should have legal experience or a juris doctorate. This meant I would not qualify. Instantly, I felt as if I was walking home with my grandmother asking her to sign me up for the children's choir.

Red flag #2. The preferred candidate would not be required to possess tenure in a civil service title. This meant I would be excluded as I was certified and possessed a civil service title. Instantly, it was the third Sunday, and I was watching my favorite choir singing. The one I wanted to belong to.

Red flag #3. The preferred candidate would be external; hence, they would be hired from the "outside." This meant I would be excluded and not in consideration for the position. Instantly, I saw my grandmother pointing in the choir director's direction.

Red flag #4. The position was scheduled to be posted, but we were not informed when to expect to see the notice. This meant, well, at that point, I did not know what to think because all I heard was, "This promotion is not for you." Instantly, I heard my grandmother say, "Ok, so let's go home."

After the planning meeting, I was a little discouraged, knowing that I would not be considered for the executive director position. I thought, "Why bother to apply?" At that point, my mind was made up. Nope, I'll pass. A few weeks later, the position for the executive director was posted. Although some of my fellow coworkers applied, no one received an email or any form of notification for an interview. We subsequently learned that a candidate was already identified for the position. Ironically, the preferred candidate possessed minimal supervisory experience, was new to the program, and was my subordinate. You heard it right, my subordinate; a person that I had supervised. All along, the promotional opportunity was created with job qualifications meant to unqualify me.

I learned that one of my managers had already painted a negative picture of me. Hence the reason I was not encouraged to apply for the position but discouraged during the initial planning meeting. We also learned that interviews were only being scheduled to satisfy the hiring policy and procedure. At that point, I had already decided that I wasn't going to apply because the leading executive already had in mind the person she would hire to fill the executive director position. But, I remembered that moment I had with my grandmother when she told me, "If you want to be in that choir, you will go and sign yourself up." So, if I wanted to be considered for the executive director position, I had to "sign myself up" and apply. She was right; no one was giving me anything. If I wanted it, I had to go for it because, despite my

experience and history within the program, the position would not be handed to me. So, not only did I apply for that position, but I also started applying for other jobs within the agency because it was clear to me that I was not being valued or respected. I submitted my application for the position, and immediately I was invited for an interview. Although I knew my subordinate was considered the preferred candidate, I accepted the interview invitation. There were two rounds of interviews. A waste of time, but I thought I would go through the motions. I was told by a coworker "in the know" that I did well during the interviews. I was impressive. I guess I wasn't the incompetent idiot my manager professed me to be. Although I left a great impression, had the experience, and was more qualified for the position, I knew it would not be offered to me.

As I mentioned earlier, I started circulating my resume, looking for other positions. Since God is always on my side and has me covered, I was offered an interview for an executive director position within the agency, but in another program. I guess you are wondering if I went to the interview. Yes, I did, and in my Sunday's best. After the first interview, I was called back for a second interview. During the second interview, I was offered the position. Of course, I accepted the job right on the spot. At that time, I had not heard back about the executive director position within my program, nor did I receive a rejection email or letter stating that I was not accepted for the job. However, I learned that the leading executive was planning a meeting in a few days to alert

the unit about the leadership changes and who would be the new executive director. I had already received confirmation that my subordinate was offered the position, and the announcement would be made very soon.

Later that day, the leading executive sent a meeting invitation to everyone in the program for 3:00 p.m. In addition to the 3:00 p.m. meeting, I received another meeting invitation, from the leading executive, for 2:30 p.m. on that same day. At that time, I did not know the outcome of my interview but I did know that my subordinate would soon be my new boss. At 2:30 p.m., I was front and center, meeting with the leading executive and her assistant. Like I had known, I wasn't offered the position, nor did they tell me who was offered the job and who would serve as my new boss; but, they mentioned that the new leadership would be announced during the 3:00 p.m. meeting. In the same breath, they praised my work, my experience, and my contribution to the program's growth. I was told how much of an asset I was to the program and was asked to support and help develop the new executive director. Really? All I could say was that I was grateful for the opportunity to interview for the position, and it was unfortunate that I was not selected. I expressed that I hoped the person chosen was qualified and had the skills to continue developing the program and me as a leader.

As per former First Lady Michelle Obama, I am an example of what is possible when girls from the very beginning of their lives are loved and nurtured by the people around them. I was surrounded by extraordinary

women who taught me about quiet strength and dignity. The leading executive and my manager thought they had won, and I surrendered by waving my white flag. In the end, I had won! My courage, determination, and strength landed me a new position as an executive director in another program within the agency. These blockades were unable to create my story and determine my future. My grandmother prepared me for moments like that. At the age of ninety-nine, she continues to provide words of wisdom. So, always value moments with your elders, as those moments will build your confidence, strength, courage, and determination.

SCALE YOUR MOUNTAIN TO SUCCESS
Charise Worthy

Charise Worthy is a certified professional coach and energy leadership index master practitioner, helping queens to beautify the inside and illuminate from within. She assists women in nurturing their five selves: self-acceptance, self-confidence, self-esteem, self-love, and self-worth.

Charise works to empower clients to develop and maintain their life plans, inspires individuals to implement positive life changes, and holds clients accountable to their own agenda. She places an emphasis on self-reflection and personal development to help women make the necessary strides to experience personal transformation and craft their own story with an understanding that strength and resolve begins within.

Learn more at www.goldenlifeliving.com

They say hindsight is 20/20 and I find this to be true, particularly in entrepreneurship. I set out on a journey to find something that was in alignment with my gifts and talents. I was commuting to a job that took me anywhere from 45-60 minutes one way to get there. I would arrive feeling exhausted, in part because I knew that I was wasting gas and mileage to report daily to a job that did not see me nor recognize what I have to offer individually. I knew after being with that company for over

fifteen years that I was not interested in moving to another company or even remaining in the same industry. I wanted more, but what exactly did more entail?

Entrepreneurship is not for everyone. But for those of us who elect to pursue this course, I want to be real—it is work that can fuel or drain you emotionally, mentally, and physically if you neglect to learn to scale the mountain. There are those that jump right in, leaving their nine to five and completely taking that leap of faith. Some may elect to continue working full-time and pursue their venture as a side hustle. Others may elect to work part-time while pursuing their purpose. Whatever course feels natural and organic for you, I just want to advise you to be sure that you scale the mountain.

I have dealt with bouts of self-doubt, losing sight of my vision for my company, listening to other "experts," and even neglecting my own self-care. So much so, that I found myself taking a year off to get back to my core.

I experienced an epiphany while engaging a guest on my podcast as we discussed fears. You never quite know how the universe will give you lessons, but I am discovering that many of the lessons I acquired were obtained during my youthful years. During this realization, I was taken back to a time when my family and I were visiting relatives in Ohio. A particular relative we were visiting lived across the street from a mountain. My cousins and I headed across the street and began to scale it. We were young and did not stop to draw out a plan. There was no safety equipment looped around our waists in the event that anyone should lose their footing.

No helmets in case anyone should fall. We did not even stop to contemplate such things nor was a big deal made about safety as it is today. We just proceeded to climb without any inhibitions or fears.

None of us reached the top, but that was not necessarily the goal. Each of us was willing to climb as high as we could go on our own. When I reached my high point, I recall turning briefly to see how high I had climbed. While I do not have the exact number of feet, I can assure you that in the event I had fallen, I would have sustained some serious injuries or perhaps not be here to share my experience. I recall taking in the view for a moment then briefly thinking, "How are you going to get down?" Honestly, it was a fleeting moment. If fear arose in me, I did not have time to entertain or nurture it because I instantaneously became focused on the solution, not the problem. While this story has not always been at the forefront of my mind, it rose up once I was in the thick of entrepreneurship and serves well as a lesson on learning to scale the mountain.

We are simply not giving credence to fear or problems, let alone allowing them to guide us. What happens along our journey is that most people, present company included, allow these things to come and rule our lives. How about allowing others to dictate or write our narrative? How about taking the opinions of others as our own? How about these messages somehow translating into we are not enough?

Scaling a literal mountain requires some basic tools; although, in our youth, we had no tools or safety

equipment as we set out on our respective journeys. Today, some may call that foolishness. I like to refer to it as fearlessness of youth. However, in my adult years, if I were to tackle such an adventure, I would ensure that I have the appropriate equipment—a helmet to protect and prevent any head injuries, a harness that offers a cradle of support, ropes to help when ascending and descending a mountain, a belay device which is a braking tool in the event of a fall, and anchors which are used to connect the belayer and climber (again, in the event of a fall).

What does s-c-a-l-i-n-g the mountain look like in my real life and as it pertains to my business and personal goals? I can guarantee you that I am not climbing literal mountains today, but life has provided me with enough figurative mountains. My problem, at times, is that I want to leap right to the top. But, my childhood lesson reinforces that if we truly want to get there, we have to not only take the small steps required, but even more importantly, we have to savor and enjoy every little step that it takes. The following are five keys I have learned along my own journey. S: Self-care, C: Clarity, A: Authenticity, L: Learn, and E: Enjoy.

SELF-CARE is essential for us to fully show up, not only in business, but in all aspects of our lives. Women are much more apt to give to others and neglect their own care. However, many times I must remind my audience, clients, and myself that it is imperative to show up for ourselves if we want to extend ourselves to others. Otherwise, we will deplete ourselves which is a lot

harder to rebound from. This rebound is not impossible, but it can be a bit more exhaustive than simply weaving in the space for our own self-care along our respective journey.

Self-care does not have to be elaborate or break the bank. It is simply identifying the ways you want to care for your mental and physical state. For instance, my eating habits can range from one end of the spectrum to the other end with nothing much in between. I have observed that when I get an idea to do something, I can become hyper focused and completely enthralled in the task. I am talking about a task I may have set out to do for one hour may end up becoming an eight-hour task or a full weekend venture. Another problem is that I may skip having a balanced meal or consume mindless snacks (never the good kind).

CLARITY is a key foundational trait as you prepare to climb your mountain. I want you to know that you already possess the gifts and talents required to fully carry and sustain your pursuits. Granted, self-doubt and even the opinions of others may prevent you from fully seeing this. There are so many things to figure out in your course of entrepreneurship and guess what? Everyone thinks they are the expert with a formula to help you get there. And with a price, of course. There is nothing wrong with building upon your knowledge in whatever way you see fit—be it a certificate, degree, or continuing education. I just want you to ensure that it is something that you find beneficial to you and your entrepreneurial pursuits.

Do not become bogged down in what everyone else is doing; it is quite exhausting to follow the crowd and attempt to be all things to all people. At one point, I was hosting a podcast, working on a YouTube channel, managing multiple social media pages, and distributing an e-newsletter via email. Heck, I am exhausted just typing these things out. The podcast was nice for connecting with others, but it was a lot of work—booking guests, sending a one-sheet, editing the show, scheduling the show, reaching back out to the guests to advise of their air dates, and creating promotional tools. It was a pleasurable experience, but one that took an enormous amount of time to pull together for a company of one.

AUTHENTICITY is a key component, in my opinion, in anything that you do or attach to your name. Too many times, people want to box others in. Oftentimes, we are culpable of boxing our selves in too. Do not try to mimic what others are doing. Put your stamp that is uniquely you on it. Some things you do will mimic what you've seen others do because depending upon the industry you are in there may be some standards you are to uphold. My core industry is coaching. There is lingo and processes that we follow. There are messages that may very well overlap or become repetitive. However, I show up authentically as me which allows me to connect with my intended tribe.

Remember that you bring your own gifts and talents to the table. I encourage you to create your own and invite those you wish to sit at it. There is absolutely nothing wrong with being invited to other's tables, just

be aware that you may not wish to sit at every table that extends an invite. In many instances, you will have to build your own table and invite your intended audience. In other words, create your own opportunity and do not sit around waiting for one.

LEARN. There is always an opportunity for every one of us to learn and grow. I whole-heartedly believe that growth is a continuous journey. Learning does not always correlate to obtaining certifications and degrees. Your personal learning journey can include reading material, conducting your own research for understanding, and networking with others to toss out ideas and gain some feedback.

ENJOY. Let me keep this 100 percent real with you— entrepreneurship is not necessarily all roses. HOWEVER, this should not feel like a chore or something that does not fuel you. That is a job. I get to create the narrative. I am empowered to decide who to connect with or who to venture into a partnership with. While I have my big picture vision in mind, which is likened to the very mountain I once scaled, there were moments where too much emphasis was placed on the peak of the mountain rather than the steps it would take to reach the top. The lesson in all of this is to enjoy the journey and carve out the time to celebrate the steps along the way. It is the baby steps that get us to the top, so never should they be minimized as they are the true gateway to success.

In conclusion, we must define life on our own terms which is also applicable to our entrepreneurial goals and pursuits. When people do things to attempt to diminish

your shine, I need you to know that their feedback will in most instances have nothing to do with you and a lot to do with their own security level. We are taking ownership of our own baggage and learning to release it, yet we're mindful not to take on someone else's baggage along the way. Next, we must define success on our own terms. Success looks differently for us individually. Success may be defined by some as the revenue generated and for others it can be based on the number of lives impacted. Whatever rings true for you, be sure to gain clarity on it as you set out on your own path, and try not to get distracted by what others are doing or what they appear to have going for themselves. Your time will certainly come. In fact, whether it is a new plan or a plan that has collected dust, the time is now to set that plan into motion. Revisit your youth occasionally for there you will find countless memories with lessons embedded into them. It was in our youth where we were adventurous, fearless, unapologetic, and willing to explore. Tap into that tenacity, for you will need it constantly throughout your journey.

Chapter Five
DON'T WORRY: YOU CAN DO THIS!
Jennifer Thomas

Jennifer Thomas is a solopreneur who helps her business owner clients manage their offices so that they can make the most effective use of their time. Jennifer strives to help others and values the human connection in each interaction. Before starting A+ Virtual Administrative Consultant, Jennifer worked in customer service as an inside sales support team member. She has also worked in banking and for her local public library, and volunteered with Soroptimist International and the American Red Cross. In addition, she hosts a monthly book club and writes her blog, *Books & Life*.

Jennifer has a master's degree in creative writing. She also has a certificate in digital media and marketing. She is a lifelong learner who enjoys reading, baking, and traveling.

To connect, email her at jennd1@gmail.com

Keep learning, always! I'm Jenn and I'm running my second business. Life threw me a curveball a few years ago and my marriage ended suddenly leaving me with a son, few skills, and no idea what to do next. The answer seemed obvious—get a job. It sounded so easy, but it was hard. I wanted to set a good example for my son. I wanted to show him that you must adapt and chase

your dreams, but it didn't seem like I was doing either of those things. At least not a first.

I tried to go back to a nine to five job. The truth was retailers didn't want me because I wasn't available on the weekend. Office jobs didn't want me either because I had been out of the workforce too long, and even if the interview went well the skills test didn't. I finally found a part-time job at a nearby bank. There were evening hours and Saturday morning hours, but my boss was as flexible as possible with my schedule. My boss knew she could teach me the details of being a teller. The truth is she taught me so much more. I was sad when I left the bank a few years later, but I knew I had to be in charge of my future, not dependent on a traditional job. I think you feel that way too. I had to ask myself, *How do I get to where I want to go*? I thought, read up on things, and thought some more. The truth was that I needed knowledge and skills.

The actual value of my bank job was the people I worked with who became my friends. They quietly reminded me that the path each of us follows in our life that brings us happiness, success, and freedom is different for everyone and getting where you want to be is up to you. They helped to restore my confidence and not one of them thought it was odd when I chose to go back to school. These wonderful women didn't realize it, but they became my village. They were always willing to offer their thoughts, hear me out, and help me with the tough decisions. Find your village. It might be good friends, it might be coworkers, or it might be your

family. It is probably a combination of all three. That is wonderful. A village that offers you different thoughts and helps you work through the tough stuff has a value all its own.

Throughout your journey, leverage your resources. Don't overlook the people you know and what they might be willing to share. Does your nephew have a successful YouTube channel? Does your daughter have lots of Instagram followers? Start by figuring out what you know, what you need to know, and the best way to learn it.

I agonized about the decision to go back to school and the cost. I was afraid of taking on the debt, even though my loans amounted to a car payment and not a fancy car at that. I was lucky. My grandparents had left me some bonds and I cashed them in. In my heart, I knew skills and knowledge were the answer. I still believe that today.

Writing and words have always been a passion for me. I tried to talk myself into a business degree, but I couldn't pull the trigger. My heart stopped me. My heart knew I would end up in a job I didn't love. In short, I would end up in the same place.

I mulled it over, and over, and over. In the end, I jumped into a writing degree with both feet. I've never been sorry. I expected my master's program to teach me how to write, but I didn't expect it to challenge me in so many other ways. I learned to use new tools. I played video games to explore the story that drives the game. My favorite project, which terrified me at the time, was

making a one-minute movie. The movie was an adaptation of part of one of the screenplays I had written. I didn't have much experience taking a picture with my phone, and now I had to make a movie? I panicked and hoped they would change the requirements before it was my turn to take the course. I fretted and worried. My professor was exceptional. I am a planner, but using a detailed plan reminded me of the value of planning. My master's program was intense; it lasted a year with a new class every four weeks. I worked part-time while I completed my degree, helped out with my grandmother, and raised my son. I was so ready for a vacation at the end of it, but I wouldn't trade a minute of it either.

That experience reminded me that I am a lifelong learner. Technology is always changing, and I must change with it. If I'd known about having to make that video, I would not have signed up for the program and I would have missed out on so much. Go after the things you want, scary or not. You will surprise yourself and those around you by what you discover along the way. Celebrate your victories, you've earned them.

The past year has taught me that education and the world are changing. You don't have to learn in a classroom; you can do a degree that is all online, which mine was. You can read a book. You can find a different kind of class. The possibilities are as different as the days of the week. Figure out what works for you. There will be more than one answer. For example, I am happy to complete self-paced courses. I also like to jump on a Zoom class for a new program so I can work through it while

I am in class. Some topics such as marketing are best for me when I read a book. Figure out what works for you and find the best sources for future learning. Social media platforms offer lots of options. Your local community college might as well.

I know starting your own business can seem daunting, but you can do it. Start small; no one expects you to be a success in your first five minutes or your first five months. Make a list of the things you are good at and could do for other people. Are your baked goods worthy of a guest spot on a TV show? Do typos jump off the page at you no matter what you are reading? Does setting up a webpage relax you? Leverage those skills to get started. Figure out the next step. Maybe your cake tastes divine, but it looks sad. Consider taking a cake decorating class at a local bakery or craft store. Bake for friends and family to get practice. As your creations become camera worthy, add the photos to your portfolio. Think about the things you can do that help make life easier for others. Those things we all stumble over, how can you help other people with them? These are the things that matter, and the clues to where your journey starts.

Begin by deciding what you want to do. Decide what you know and what you need to learn. Become a sponge. Soak up every drop of knowledge you can. Be resourceful and stay organized. I start my day by enjoying the quiet of the early morning and reviewing my list for the day, then I jump in with both feet. I give thanks at the end of the day. I celebrate the victories no matter how small and learn from the mistakes. Even the worst

experience has valuable knowledge to share with us. My divorce taught me that the best person to rely on is me, but I am not an island and I need people in my life. I choose wisely. I think before I jump, but when I jump, I dive in with both feet and give it everything I have. Some days that isn't as much as it should be, but other days I am in the zone and I give over 100 percent. Do the best you can. When you have a rough day, regroup and start over in the morning.

Surround yourself with people you admire; you will learn valuable lessons from them. Once you get settled, reach out and help others when you can. Trade services, lend support, and be the person you want to become one day at a time.

My path has been different. I've found clients from lots of places, and I'm always adding skills. I'm working on improving my knowledge and skills in social media. Then, I want to learn about marketing, video editing, and mastering graphics programs. Those skills will help me to help my clients and they might lead me to another service I love. If I love it, I can add it to my services and get paid to do what I love. One important note about adding to what you do : try to add skills that complement what you already do. Add skills that build on the skills you already have. Since I am already learning social media, learning about video creation and editing would be a natural next step since videos can be part of social media content. If you own a car repair shop, a course in making videos might not be the best next step.

You never know where your new skills might take you. Be open to the unexpected.

My graduate work has led me into social media and teaching. I find I enjoy teaching and I'm considering working for an online teaching provider part-time. I do not want to give up any parts of my dream yet, I want to keep expanding it. I know the time will come to make the hard choices, and I will, but for now I'm enjoying the experiences. Starting your own business and being the master of your fate sounds glamorous and wonderful. Some days it will be. But there will also be days that are hard, tiring, and might leave you with self-doubts. These days are important. They forge you in fire and you come out better for it.

Put systems in place now while you are still learning. I leave time in my morning to enjoy a cup of coffee. I mentally review the day ahead before I get up. Those quiet moments give me time to think and be ready for the day. I look ahead to the next day at the end of the current one. And before I go to bed each night, I take the time to be thankful for the day. Take this time while you are building skills and your client base to figure out what works for you and what doesn't. If you're a night owl, use that to your advantage. I am more of a morning person, so I get up early and try to finish my day before dinner time. If you plan to start your business before you leave your nine to five, you might have to work in the early mornings and the evenings. Just find your groove and make the most of it.

I am always moving forward, and always planning the next skill or class or tool I want to master. That doesn't mean that I don't rearrange the list. Having a plan is important. Even if that plan only includes the next step you take, it has value. I love Trello to keep myself organized, but I also have a paper list and folders full of notes. I enjoy having one foot in the world of technology and one arm in the paper place. You will find out what works for you and whatever it turns out to be is ok. There is no right and wrong as far as tools and methods are concerned. If your work is high quality and your clients are happy, then keep doing what you're doing. There will always be fresh ways to do things, but you must decide when and if those changes are right for you. Think of it as a buffet: choose the main course you want (i.e., your skills and niche), then choose your sides. Think of those sides as the complimentary skills. For example, if you shoot and edit video, think of skills like graphics that complement your major areas of expertise.

I've made it a habit to always be thinking about what I want to learn next. There will always be a next for me—new programs, new platforms, and fresh ways of doing things. I am in this for the long run and I intend to make it to the finish line with a plan, not by chance. Education and skills that will help me to help others are my best way to do that.

It is great to have a niche and a solid client base, but if your heart leads you in a different direction, it is ok to follow it. Many business owners start with a skill and a dream, but our dreams can change and improve. Your

heart will lead you in the right direction, but you will need quiet to hear it.

My last piece of advice is: Learn, do, and grow. Learn to hone your skills. Learn from those that have knowledge to offer and help where you can. Do things like help your clients, your friends, and your family. Join a few groups both virtual and in person. Grow your dream and follow your heart. The only path that matters is the one you are following. It won't be a straight line, but you will get there one step at a time.

BE GRATEFUL FOR EVERY SINGLE EXPERIENCE

Sheryl Walker

Sheryl Walker is an educator and has facilitated over 100 one-on-one adult coaching conversations. Her writing is inspired by her journey and those she has coached professionally. Her books are centered around personal growth through learning, self-reflection, and daily writing. Daily writing has often served as an enlightenment ritual for her as a way to endure life's most challenging moments.

Sheryl is the author of: *More Grateful: A 21-Day Writing Journey to Increase Gratitude*, *Waiting Well: A 21-Day Writing Journey to Increase Patience*, *Forgive Anyway: A 30-Day Writing Journey to Total Forgiveness*, and *Love Poems to God*. She enjoys writing in her leisure.

To connect, email her at sherylawalker@gmail.com

If I were to write a letter to my younger self, I would tell myself to live in a state of constant gratitude. Give thanks for everything—even the pain, loss, missteps, betrayal, and perceived failures. This is a needed part of the self-development process. The key is to heal, process the experience, remain open to learning a better way, and strive not to repeat the same mistakes. All challenges create opportunities to develop wisdom or have an awakening, you just have to be keen enough to find the

treasure in the trial. I'll tell you a bit about a few per-
ceived missteps.

Most of us have endured the terrible job, the health
scare, or the many humbling moments of life where you
are knocked off your high horse. Let me explain. I'll be-
gin with the terrible job.

I started my career in a field that was not aligned
with my skill sets. I have always been a creative and
mentally organized person, so I decided to major in
accounting to sharpen my attention to detail. I did not
have an interest in this field, but I wanted to learn. Yes,
I went into a field that was NOT aligned with my pri-
mary strength. Perhaps that was my first mistake, but I
had the intention to grow. And we all know what growth
and personal development entails, right? It's painful to
grow—and I mean, excruciating at times.

So, I struggled to understand certain aspects of the
accounting content, like cost accounting. Any of my
former accounting majors can relate. Cost accounting is
brutal and separates the accountants from the non-ac-
countants. I got a low grade in that class. I've always
had a high academic standard for myself. Low grades?
I don't get low grades. I am an A student. But I did get
a low grade in cost accounting. It was embarrassing. I
cried and went into a dark place. My self-worth had al-
ways been attached to me being a good student. But to
be honest, I had rarely been challenged academically.
Most things came easily. Now at the tender age of 20,
my self-worth was being questioned.

What I didn't realize at the time was that being successful with this coursework was going to take more effort. I would need to dig deeply into that content. I visited the professor's office hours, but I did not put in the extra work on my own. I approached cost accounting as I had approached everything else in my life related to academics up to that point: I showed up and did the homework.

So, what did I gain from that experience? Resourcefulness, resilience, grit, hustle, and insight into my own learning style and process. If I'm not understanding something, I have to put in extra work to research, have conversations, compile my own notes, and really work to understand. I am grateful for that experience because it taught me how I learn best. I have to roll up my sleeves and dig in. Understanding how I learn best has served me well in life.

Despite knowing that accounting was not the career path for me, I worked in the field for a few years, gained a few lifelong friends, built up my work ethic, then moved into the field I had always known would be a good fit for me—education.

I learned from the seemingly false start in my career trajectory that it all comes together for our good. Discovering what you don't like is equally as important as discovering what you do like. My misery in accounting led me to my first love, education. The initial accounting route didn't even waste my time as I gained friends, skills, and clarity of my purpose.

Next, let's talk about the health scare. Fast forward: I grow up and decide to have a baby, and guess what? My baby arrived during the COVID-19 pandemic. I almost lost my life because my blood pressure became elevated and the hospitals were chaotic. It was not fun, to say the least. People were dying at alarming rates, but I gave birth. I knew I was extremely blessed to be able to have a baby during that time which led me to reflect on how I could use that season of death, darkness, and uncertainty to give thanks for the miracle I had just birthed and see the blessings in the trial despite the chaos at the hospital that nearly killed me.

My experience of giving birth during the COVID-19 pandemic showed me that we have it better than we think. When we are in good health, we think nothing of it. We take advantage of our blessings. It is only when our health is compromised that we remember how fortunate we are for the times we did feel well. Furthermore, hearing about other people's challenges can make our own seem very small in comparison. There are people bound to hospital beds with terminal illnesses, and those without a job, food, family, or friends.

I remember a man once telling me, "Physically healthy people have no right to be unhappy." Consider those who did not wake up this morning, leaving family members to mourn deeply. Consider those who are suffering due to poor health, who are bound by pain or unable to move around and live freely. There are many people who have to rely on others for their basic mobility. If you have the gift of breath and good health, you have much to be grateful

for. Look around at your life and all that you have. You have to see the joy and beauty, even if it seems incredibly small and limited. You have to see the opportunity that is wrapped in hardship. Don't discredit the small moments of joy, laughter, and bliss, or the tiny blessings throughout the day. We must count our blessings.

Next, let's discuss the moments we are knocked off of our high horse. Yes, I am talking about humbling moments when you think you have finally arrived, then you meet demotion and setbacks. I was born in Jamaica. I came to America when I was four years old. My mom came here years prior to find work and prepare for the family's arrival. In Jamaica, she had been a teacher, but she was unable to find such a position in the USA. She had to start at the bottom again and work her way up to become a teacher. She often worked two or three jobs at a time. I guess those were Mom's "knocked off her high horse" moments.

I too have had setbacks and had to start from scratch. I started in accounting, then took a major pay cut to become a teacher, then went through seasons of promotion and perceived demotion. But, every demotion was really a sacred season to refine my craft and become laser focused as an educator. I positively impacted a greater amount of children because of those seasons. I was able to reflect on my experience and consolidate my learning and understanding. We all need to capitalize on those seasons of rest and refinement.

My mom had dreams of a better life. I'm positive my grandmother and great-grandmother had similar

dreams. The dreams came true, but not without familial sacrifice and humbling moments. I am grateful that my mom did not give up when the path to success was no longer linear. I am glad she persevered and was forward thinking.

So, what did I gain from the many humbling experiences that appeared to be setbacks? I learned that there are many dreams and prayers that precede you; we are basking in the answer to generational prayers. We tend to worry about whether certain things will ever truly come to pass or not. But if we remain faithful and obedient, they often do, in the perfect time.

So, the bottom line is this . . . I've often had long spells of questioning the purpose and intentions behind an event in my life. I've asked myself, *Why am I enduring this challenging season in my life?* Usually, the event only makes sense when you look back over your life. Every misstep, mistake, detour, and rejection was necessary for my personal growth and development. I may not see the why in my own lifetime, but generations will reap the harvest of the seeds I've sown through my trials. It is important that I heal, extract the lesson, try not to repeat the mistake, and pass the knowledge on to future generations.

So, friends, even in the most challenging situations, there is ALWAYS an ounce of beauty, a speckle of hope. It could be a breakthrough to a situation or an unexpected angel that walks into our lives. If we were to track our life experiences, we would see that the good far outweighs the bad. Every hardship has hidden blessings.

Everything serves a purpose. Today's worries and pain become tomorrow's wisdom and growth. The hardest things in life teach us the most. Our experiences are our teachers. Our insight and depth of understanding of life flourishes from challenges.

The knowledge gained can serve as a reference point to give informed opinions and support to someone else enduring the same challenges. It might be the inspiration for a poem, song, or book. No time is ever wasted.

While in a dark place, it's hard to imagine moving into the light. It feels as if life as you know it has been altered. Every scary moment filled with fear and stress is an opportunity to learn and grow.

Every long waiting season perfects our character. Nothing lasts forever, the good or the bad. It has been my faith and hope that has allowed me to endure.

The terrible job provided me with close friends, a strong work ethic, and tech skills I still use to this day. The health scare taught me to care for my body and not to take wellness for granted. The many humbling moments in life when I was knocked off of my high horse continue to remind me that nothing—NOTHING—is by my own doing, and EVERYTHING serves a purpose. My parent's courage and sacrifice changed the entire trajectory of my life and those of the generations to come after me, even though my mom had to start over. So, all setbacks really are a set up for elevation. Success really is a journey, and the path is never linear.

There are times I can't believe I am saying thank you for the pain of disappointment, mismanagement, strained relationships, moments that felt inhumane, and how I still handled it all with grace. How could I be grateful for those things? I am grateful for the time and space to heal, process, and extract the lessons from the experience. I am grateful that unfavorable circumstances kick-started my work in other areas of my life that needed my attention and appreciation. Those situations allowed angels into my life and deepened my dependence on a Higher Power, since they revealed my own human limitations.

You must shift how you process your experiences; they should not be condemned. This one notion has elevated my entire life and helped me to endure challenges.

Strive to be grateful for everything that comes your way. Give thanks in all circumstances, both the good and the bad. For even through challenges there are lessons, blessings, and abundance. Do whatever it takes to shift your energy and focus on all that you have gained. Keep enduring and saying thank you. It is always too soon to give up!

Chapter Seven
FAILING TO SUCCESS:
REBOUNDING FROM SETBACKS
Cassandra Hill

~~~~~~~~~~~~~~~~~~~~~~~~~~~~~~~~~~~~~~~~~~~~~~~~~~~~~~~~~

Cassandra Hill is a wellness coach, holistic health practitioner, author, and speaker. After overcoming systemic lupus with a regimen she developed, Cassandra birthed Holistic Living Consulting. Her mission is simply to empower women to achieve physical and emotional wellness. Holistic Living Consulting guides women to rid their bodies of dis-ease with natural solutions.

Learn more at www.cassandrarhill.com

~~~~~~~~~~~~~~~~~~~~~~~~~~~~~~~~~~~~~~~~~~~~~~~~~~~~~~~~~

Many famous people have humble beginnings. Oftentimes, you notice them reaching their destination but you missed their journey. Did you know that Michael Jordan did not make his high school varsity team as a sophomore? He locked himself in his bedroom and cried; however, he did not give up on basketball. Michael Jordan practiced and practiced then became a star on the junior varsity team. In his senior year, he made the varsity team and became a McDonald's All-American player. Now, the part of the story you are familiar with is him winning multiple championships in the NBA and the billions of shoes sold across the world.

Walt Disney, known for creating famous characters like Minnie and Mickey Mouse, dealt with tons of

setbacks before becoming a household name. His movie *Three Little Pigs* was rejected by distributors for not having enough characters. Walt was told by MGM Studios that Mickey Mouse would terrify women on the big screen and would not work. His first animation business was dissolved. Walt was unable to pay rent and ate dog food. However, he never lost faith in his vision.

After I completed graduate school, receiving a master's degree in gerontology, my career had many peaks and valleys. My first career position lasted less than five months. The company was not a good fit for me. It was a tough decision, but I walked away from that opportunity. Upon starting my next opportunity, I received a $10,000 salary increase and really started laying a foundation for my career.

Working in my passion attracted additional opportunities and recognition. Other companies learned of my work and I was recruited for contracts with major senior care companies. The National Association of Professional Women recognized me as VIP Professional Woman of the Year. Throughout my career, my health waxed and waned which created roadblocks to reaching the next level. Despite the challenges, I spent nearly a decade working in the senior care industry. The rewards of a fulfilling career were great; however, God had a different plan for my life.

After having years of medical problems, I was diagnosed with systemic lupus. When that diagnosis came, my life changed and my calling to heal women manifested. Starting a business proved to be one of the hardest

endeavors I have experienced. Investing time, energy, and money and seeing extraordinarily little return on investment can be frustrating. While pursuing your dreams, the important thing to remember is your why.

Why are you wanting to achieve this dream? Spend time alone and discover what motivates and drives you. This knowledge will help ground and establish you in achieving your dreams. If you want to live like no one else, be willing to live like no one else. As I previously mentioned, greats like Michael Jordan and Walt Disney did not have an easy start, but they pushed through to make their dreams a reality.

There is no shortcut to success. Be willing to make mistakes and learn from them. The blueprint to success does not exist. Everyone has their own journey to success. One common theme is passion and determination. Start your journey walking in your own footsteps.

The power of your mind is astronomical. Every day there is an opportunity to grow and impact your sphere of the world. Having a higher-level method requires you to live life on your own terms. Do not be afraid to charter new territory. Most people will not understand your reasoning regarding certain actions or decisions, but that is fine. Sometimes you will find yourself lacking support from those closest to you; that is the time to re-evaluate those relationships. Are those people hindering your growth? Many times in life we hold on to relationships that God only placed in our life for a reason or a season. Letting go of something good makes space for great things to take place in your life.

At the time of this writing, I have been in business for two years. Sitting with God and listening to Him has provided the opportunity for me to think of visions I never imagined for myself. When I started my business, I simply wanted to help people heal their bodies. There was no plan to be featured on NBC, FOX, or CBS. My intention was not to be in magazines such as *People You Need to Know* or *Creating Your Seat at the Table*, or on the front cover of *Glambitious*, and more, but because I was willing to step out of my comfort zone, those opportunities manifested.

Higher level means just that. Step up your game! No matter the sacrifice, stay focused on your dreams. The struggle is part of the process and many times makes the reward better. You are ready to reach the finish line but there are lessons to be learned along the journey. If you were to make it without doing the work, it would not sustain. Appreciate where you are today and determine the lessons you need to learn.

Hopefully, you have discovered that the best things in life manifest with hard work, patience, and sacrifice. Take off your rose-colored glasses looking into the lives of "famous people" and realize that many of them started at the bottom. Tyler Perry was homeless before generating millions of dollars in the entertainment industry. Remember the examples mentioned in the earlier part of this chapter. Everyone has to start somewhere before reaching their destination.

Trust me, I understand this is a tough lesson to learn. There are times I struggle with being patient as well until

I remember that everything happens in its season. Stay motivated on your journey and remember to keep your mind focused. Here are a few things you can implement as you strive for the higher-level method.

1. Become a student and take courses geared toward improving your strengths.

2. Create a support circle of three to five people who have visions and can serve as accountability partners.

3. Consistently reading books on a variety of topics is imperative for your growth.

4. Creating a vision board will help you to remember your goals.

5. To accomplish greatness, your body needs to be whole. So take care of your physical, emotional, and spiritual health. Your higher level is waiting for you.

Chapter Eight
LETTING GO OF FEAR TO PURSUE DREAMS
Dr. Kayra Alvarado

Dr. Kayra Alvarado was born in Panama City, Panama. She is a seasoned educator and has a PhD in education from the University of Maryland. She started a blog in 2017 that allowed her to showcase her passion for style, share words of wisdom, provide exposure to women and minority-owned businesses, and spread awareness on service initiatives that supported people in need. She has been able to acquire a strong community of loyal followers, numerous collaborations with businesses, and sponsorships with fashion brands such as Ann Taylor, J. Crew, Maggy London, and Nine West. One of her greatest achievements is a long-term sponsorship with Bumble that allowed her to host events in St. Louis that afforded women with business workshops as well as memorable social experiences. She is the author of *The Digital Transfer* which provides key principles on how to establish a dynamic digital presence.

Learn more at www.kayraalvarado.com

I want to send you a big, loving hello and I truly hope that the stories shared by all of the dynamic women in this book serve you and fill you up with the energy to execute your professional and entrepreneurial dreams.

My story is a celebration of how dreams do come true when we believe in ourselves and refuse to let the inner critic as well as the outer world determine who we need to be and how we show up. My dream was connected to working in the fashion industry and being able to model clothing for a living. I vividly remember as a child how much I loved styling my Barbies. When I went to college, I was able to join a fashion club and model clothes for our fall and spring productions. Participating in those fashion shows sparked a joy in me that I couldn't compare to anything else. After graduating from college, I became a teacher and let go of my passion for fashion because I was sold on the belief that I had to focus on a profession that was serious and dependable. I absolutely loved being a teacher, but after several years of being in the profession, there was a piece of me that felt neglected.

Unfortunately, I was always filled with excuses and I gave myself additional tasks that I should complete before I could put myself out there and build anything that allowed me to exercise creativity. I spent many precious years thinking and dreaming about how wonderful it would be to work with fashion brands and potentially model and style clothing.

I finally decided to start a blog about fashion and reflective life experiences. It was mainly built because I was experiencing a very challenging time in my life. I was living in the Midwest, away from my family and friends, and my marriage was broken. My blog completely rejuvenated me, serving as a space to dream again, connect with other people, and build something that allowed me

to blend my love for clothing and styling. I was filled with fears about whether I was a good enough writer, if others would judge me for this endeavor, what people would think about my style, and if I had what was needed to be successful in this space. Was I creative enough? Was I smart enough to navigate the digital space? Was I too old to try something new? I look back at those fears and I am so proud that I didn't allow that nonsense to get the best of me. I decided to cast out the fears and to dive into exactly what I wanted to do with intensity and passion, and fully accept any mistakes that I made along the way. Acknowledging that mistakes and errors are completely normal was essential for my beginning because I could easily see how the pursuit of perfection had placed me in a space of paralysis for a very long time.

The number one thing I wish I could have told my younger self is to believe that you have what it takes to accomplish the idea that is stirring in your head. It's very common to be insecure and second-guess your abilities, but if it's in your heart and you can see it vividly, it's there because it's yours to birth into the world. For a very long time, I didn't have the confidence and the courage to pursue the things I wanted, and I wish I knew I had what it takes. So friend, please begin. Start as soon as you have a passionate idea and keep moving forward, regardless of whatever storm, mishap, or even inconvenient circumstance may come your way.

I had no idea how to start my blog. So, I ordered several books, attended a few conferences, and read

numerous articles. My thirst for knowledge was insatiable. There was a moment where I was having too much fun learning but not truly doing anything tangible. I gave myself a deadline that positioned me to execute my first blog post even if it wasn't perfect. That was very key for my success and it's still something I have to do to ensure that I achieve my goals. Taking your first step is a breakthrough toward your desired path. And when you do it, you should be very proud because the lack of this initial step is what keeps so many from realizing their dreams and mastering their desired goals. But the next challenge is keeping the engine going. At the beginning of my blogging journey, I had to learn everything that was required: how to create a site, how to market my blog posts, how to establish community in the digital space, and how to keep my followers engaged. I genuinely felt overwhelmed at times, but I knew that I had to take things in stride and keep pushing. The hours that I poured into my blog were plentiful, but I likened my blogging journey to the hours that one puts into an academic degree; the only difference was that I was running the entire show.

My blog fully runs on my internal drive and willingness to write, create content, and promote it via social media. You need to build a strong discipline muscle to show up for your business the same way you show up to your job. I would argue that you have to show up in a much larger way because it's your job to sell the value of your creation and if you aren't giving it everything that it deserves, your results will not reflect what you desire.

I was able to translate my grit and hard work from my former achievements and recycle that same level of focused energy into my business. That type of discipline allowed me to see results and to acquire success that was in alignment with my dream.

Throughout my journey, I have experienced amazing achievements where I have worked with household name brands such as J. Crew, Ann Taylor, and Nine West, and my inbox is flooded with people who want to work with me. I have also experienced seasons where the emails are few and my motivation is low. I have learned that it's critical to know how to handle all of these seasons. I am thankful that when business was slow, I never threw in the towel or believed that my journey was over. I continued my walk and I always chose to rededicate myself to my endeavors. Because of that, growth always occurred.

Mastering your entrepreneurial commitment and drive in the midst of unforeseen circumstances is key to your success. I will share an example of how important it is to push through with your business, even in the middle of hardship. After building my blog in St. Louis, which consisted of a strong base of followers and relationships with brands in that area, I decided that it was best to move back to the Maryland-D.C. area because of my divorce; I needed to be close to family and friends. Although the move was critical to my well-being, I knew that my business would be impacted on multiple levels. I still loved my blog, but I found that my energy was limited, and I was filled with doubt as to whether or not I

could build new brand relationships in the D.C. market. The same voices of doubt made their appearance again, prompting me to second-guess myself and reconsider whether or not my blog was worthy of any attention or energy. I took several months off to reestablish myself, focus on my work as an educator, and ensure that my daughter was adjusted to our new circumstances.

Several months passed. I kept thinking about my blog and how I was grateful for the time to rest, but I knew that I had to take the needed steps to continue. After eight months, I restarted my blog with some fears about how people would respond. I was stuck with a pessimistic outlook and assumed that my community would find it odd that I was blogging again after taking such a long break. I also thought that brands may not want to work with me because of my break. All of those thoughts had to be put to rest and I had to press forward with my business, even if it felt awkward or challenging that I had experienced personal and entrepreneurial challenges. When I decided to show up again, I found out how much my digital community missed my presence and my content. Since that experience, I have learned that successful entrepreneurs master their goals by managing their thoughts, emotions, and drive.

It's striking to see how we can be our biggest critic and if we just get out of our own way, we would be able to see that there's space for us to be and become everything we want to be. Since I recognize how much our own voice can limit us, I counter it with all of the motivational content I can find. Every time I listen to

resources that share stories of triumph, even in the midst of adversity, it truly helps to strengthen my mindset and fortify my drive.

I'm also fanatical about writing lists, creating vision boards, and saying words of affirmation related to my business. I like to think of my business as a garden that is deserving of unconditional love. And I have made a commitment to create a beautiful, magical garden that has a lasting legacy to inspire and empower others. If you realize that your commitment is for the long-haul and you expect there to be a number of highs and lows, you won't over think, over analyze, or get in your own way of building and keeping up with your business. Establishing a plan with an outcome goal that is several years away will support your survival through storms that aim to break you and your business.

In the end, I would say that the most important thing I did well was submit to the journey and show up for myself over and over again. If we go back to the beginning of this story, I could have allowed fear to consume me; I could have stayed in the planning phase, learning how to blog; or I could have even stopped after a few blog posts. But I didn't. Now, something you should know is that I did work hard, but I have made many mistakes throughout this journey and I am still learning. But because I decided to show up, opportunities have presented themselves in my business and in my life.

We all have crazy dreams that we might be too scared to share. But what you need to understand is that if that dream was put into your conscience, it's there for

a reason. Don't beat yourself up if you only take baby steps. As long as you are moving forward, you will be happy that you kept moving. Also, don't expect everyone to be sold out on your dream. It's your vision. People won't understand what's in your head or what you believe about what you deserve until you show them. Protect your dream the same way you would nurture and love a child. Just like children, your dream will frustrate you and sometimes make you feel crazy, but at the end of the day, there's nothing in the world that can replace the love you have for it. And last but not least, be confident in your gifts and what you have to offer. The world is waiting for you to show up.

Chapter Nine
LOYALTY AND TRUST
IN THE WORKPLACE
Jennifer Hallman-Almonor

A Brooklyn native, Jennifer Hallman-Almonor has committed her professional life to the public education sector. Jennifer began her career in education at an elementary school in Brooklyn where she taught for eight years as a cluster and fifth grade teacher. Armed with a strong background in curriculum development and contemporary teaching strategies, Jennifer worked diligently to develop a new generation of children into motivated and directed young people. After teaching for eight years, Jennifer left the classroom and became a school counselor, working at a transfer school in Manhattan where she remained for fourteen years.

In September 2019, Jennifer took on a new role as a college advisor, helping students identify their strengths and define their future career paths. Jennifer has been a member of Sigma Gamma Rho Sorority, Inc. for 25 years. She resides in Brooklyn with her daughters and her mother.

To connect, email her at JLAlmonor@gmail.com

Often, when you think of family and friends, you think of togetherness, loyalty, and trust. Growing up, my mother always believed in family and treating friends as family.

Loyalty and trust became important aspects of developing and maintaining long-lasting friendships and relationships. My mother, Daisy, was born and raised in Columbia, South Carolina. She continuously stressed the importance of education and being true to yourself. Upon the passing of my brother in 2001, with her guidance and unconditional support, I decided to advance my education and pursue another master's degree in school counseling in the hope of helping students cope with unexpected and tragic events in their lives. My own experiences adjusting to life without my brother made me more sensitive to the emotional aspects of human development and more astute to the importance of the general mental well-being among school-aged children.

I received a bachelor of science in public administration and a minor in health planning and management from Alfred University. I also hold a master of science in educational administration and policy studies (K-12) from the State University of New York at Albany and another master of science and advanced certificate in school counseling from the City University of New York at Brooklyn College. Additionally, I have a permanent New York state license in school administration.

As my friendships developed personally and professionally, I learned that the concept of "loyalty and trust" does not mean the same to everyone.

As the sole school counselor at a small transfer high school in Manhattan for 11 years, my role varied. But, the ultimate objective was to ensure that the students graduated. As an extension of that objective, it was always

important to me that students understood the why. Why is it important to obtain a high school diploma? Why is it important to go to college or have a trade? Why have I dedicated my life to educating students in the inner city? It has always been important to me that students know I come from the same neighborhoods they come from and that I am empathetic about their challenges; but, in life we make choices that can determine our outcomes. I have always encouraged my students to think deeply about their choices.

As a person who believes in elevating students and being a team player, I worked beyond my job title. From 2005 to 2015, I was the only school counselor that was responsible for the day-to-day function of programming, scheduling, counseling at-risk and mandated students, sitting on the school cabinet, and interacting with our field support liaison. The bonus and privilege was that I always secured guest speakers for graduations which was the highlight of the year for me. My desire was to get a guest speaker the students could relate to. Someone they could identify with. Speakers included: New York state senators, doctors, and motivational speakers.

At the beginning of one school year, a friend of mine who was also an administrator came to my office and noticed that the supervisor moved from his office and someone else was there. She asked, "Did they hire another guidance counselor?" I replied, "Yes, they wanted someone for our bilingual population." She immediately said, "Be careful. There's no need for them to have another guidance counselor. Your school does not meet

the need nor does your school have the numbers." I did not think any more of it because I knew the guidance counselor. She was a former school aide with whom I worked closely, and who I mentored when she decided to pursue a career as a school counselor. We were not just colleagues, we were friends. We cried on each other's shoulders. We attended each other's celebrations and our children's celebrations, talked on the phone with one another, and even discussed taking our children on a Disney vacation together. This was not a fly-by-night friendship.

On March 27, 2017, the citywide PSAT and SAT day, we were in the auditorium supervising students who did not have to be administered the exam. Our immediate supervisor said, "I'm seriously thinking about retiring and I really need you to look out for one another because things are changing. You make sure you watch each other's backs. You're sisters." That was nothing to me because I have always been that person to look out for my friends and colleagues, no matter the situation. Loyalty is important.

We were speechless, as we both were aware of the changes the new leadership was making. I remember us looking at each other with our eyes wide open. As time went on, I observed the cohesiveness between myself and my "friend." It seemed forced and less genuine, especially as I look back on it now and when I have conversations with people about the sequence of events.

There was an instance when we had to perform a task for potential holdovers and submit data to the

citywide system. When the pupil personnel secretary went to confirm its completion, she noticed that half of the school's population was not included. She immediately called me to confirm that I met the deadline. I informed her that my potential list was entered into an automated system. But, it was my colleague who did not submit hers because she was absent the day it was due.

I felt as though I was always left to do all of the work, as if I was still the only school counselor. Other than our administrators, I carried the same workload as if I were alone. It was I who scheduled and organized college tours. It was not until the day of the trip when I received the help that I needed. My counterpart was always included in the planning. As time went on, I noticed the changes in her behavior. I did everything I needed to do and remained professional. After all, I was there for the students.

It was September 2018, and every school in New York City must meet their enrollment targets by October 31. If not, the school loses a portion of their funding allocation. If a reduction in funding occurs, the dynamics of the school changes as well. If a school does not meet their numbers (essentially, the number of students on the register) by October 31, they lose money and staff in the following school year. In June, all employees receive an evaluation and rating sheet. In June 2019, I received mine earlier than usual. I was informed that I would be excessed due to the school not making our numbers. All I remember hearing was, "Sorry but I have to excess you. If you need anything, please let me know.

I looked for ways to keep you, but they said we have too much support staff." I was left in complete shock, as I was one of the hardest working staff members in the school, going way beyond what was required. I maintained an impeccable attendance record and work ethic. My relationship with the students, past and present, was beyond reproach.

I was hurt and disappointed for months because the person I thought was my friend did not acknowledge the fact that I was no longer going to be there. She claimed she was unaware of me being excessed, but I know otherwise. Not once did she ask if I needed anything. The calling and texting ceased; all communication was cut off from her end. Not once did she inquire about how I was doing, whether or not I secured a new position, or how I was managing this significant transition.

I am glad to say that I secured a position in a wonderful school, but I remain extremely careful when forming new work relationships.

As I look back over what occurred during the past few years, I realize that the writing was on the wall. Loyalty and trust in education is few and far between. I would not say they are nonexistent, but the lack of loyalty and trust does not just happen in businesses and corporations. In the new educational system, it is every man and woman for themselves.

During the time of me being excessed and not securing a position where I would like to have secured one, my mind was cloudy and I had so many emotions. I was in denial, depressed, lonely, and devastated. I asked

myself so many questions. *What could I have done differently? Did I exhibit too much integrity? Did I go against leadership one too many times? Was I too comfortable? Was I no longer a good fit for the school? Did I feel confident enough in myself that I could find another job?* I received opportunities from all over the city, but I could not and would not compromise myself. I had been in education for over 20 years and had not updated my resume in years. I am a planner, and this was not in my plan.

Many would think finding a job in education would be easy, but things have changed drastically from the time I entered the system. Principals no longer hire you based on knowledge and professionalism; hiring is now based on salary that they can afford and nepotism. Teaching in New York City has become incredibly competitive. I did not know where to start looking. I often heard that the hiring system used, a database where educators throughout the city would look for positions, was extremely competitive. And, knowing "the system," contractually, schools must post open positions, but many of the potential hires are already selected prior to interviewing at a school.

Unfortunately, I did not find a school prior to the start of the school year, so the district placed me in a school one and half hours away from my home. It was truly heartbreaking waking my children up so early and leaving the house at 6:30 a.m. to ensure that they were at school on time and I arrived at work on time. I also had to make sure my mother was up, and I administered her

medication prior to leaving for work. My job assignment was an inconvenience, in terms of location. I traveled to East Harlem dreading having to ride a bus and two trains every day for two weeks. I filed a travel hardship; they said it would take weeks to hear back.

On September 15, 2019, I received an email from a principal that was looking for a counselor. I accepted the interview immediately. I was not offered the job on the spot, but the interview went well. She had already contacted my former principal to inquire about why I was excessed. I received an email that evening that I was HIRED! No more traveling four and half hours daily. In November 2019, I received a letter denying my request for a travel hardship.

I would not change anything that I have done. Not accepting job opportunities forced me to have faith and know that we are placed in situations for a reason and things happen the way they are supposed to. Looking back, me being excessed was supposed to happen. I am in a better place emotionally, mentally, and spiritually.

As an educator and one who believes that every child deserves a quality education, I will continue to serve the public with integrity and a strong work ethic, and accept and learn from past experiences. Loyalty and trust still exist, but it is important to recognize that when change occurs, you should either address the situation, ignore it, or start making moves to make your work environment a better place. I now know and understand that change is alright. Change is good. Change is accepting and realizing that I do not have to sacrifice or alter my ideologies to please other people, regardless

of their status. Though I enjoy being in my new school, I am more reserved. Education is the new business in the world as we know it; it is no longer a profession where you have educators who are genuine, sincere, and happy working with children within the inner city. For some, it is about securing a way to get their loans paid off or reduced or working in the inner city because schools in more affluent areas are not hiring new teachers.

YOUR LAST DRINK OF WATER
Regina Perry, MBA

A native of Long Island, New York, Regina Perry is the youngest of two children born to Ernest Perry Sr. and the late Bernice (Bunny) Perry. A world traveler, she has made her way to numerous places such as Spain, London, Paris, Germany, Alaska, and Hawaii, just to name a few. Besides traveling, Regina enjoys Zumba, volleyball, and shopping, and she has a passion for cats.

Regina holds an MBA and a bachelor's degree in speech pathology/audiology. Her current position is marketing assistant to the director of firm development at a Fortune 100 financial services firm.

Prior to joining her present employer, Regina was a geriatric case manager, quality assurance manager, and a 911 operator. Her calling for helping others in the community led her to become a member of the National Coalition of 100 Black Women, in which she is an economic empowerment and public policy constituent.

To connect, email her at regina.perrymba@yahoo.com

My mother always said, "You never know who will have to give you your last drink of water." She invariably made that statement when I was a little girl, before I was old enough to know its TRUE meaning. She would leave it at that, just hanging in the air, not that further explanation was necessary. It was my mother's way of

reinforcing that people should be nice to each other because you never know what is around the corner. I think Ralph Kramden on *The Honeymooners* said it best, "Be kind to the people you meet on the way up, because you are going to meet the same people on the way down." I love *The Honeymooners*!

So, throughout my life, that statement has been ringing in my head, whether I want it to or not. You know how you become your parents when you get older? How you realize that you really WERE listening to them, when most of the time, as a teenager, you were trying not to? I am so glad I listened.

I wear so many hats that I could open a hat store. I have been a child support investigator, 911 operator, and a case manager, just to name a few. All are extremely stressful jobs. Rewarding to the individuals who need the services, but difficult on those performing the job duties. I am not complaining, I'm just saying.

Fast forward to my former job as a case manager. I provided services to the geriatric population—home-care, entitlements, food, financial advice, and a listening ear. It was a very demanding job. Sometimes, I felt like I needed a case manager by the end of the work week. I was drained from listening to everyone's problems, and I am not the type of person who could leave those kinds of issues at the office. My most taxing case was assigned to me when I basically had one foot out the door. Now I realize that if I had not experienced the extreme challenges I had with that case, I would not be able to write

about it ! I have learned to look for the "blessings in the messings."

Mrs. Maxwell and her husband, both in their 90's, had just lost their 49-year-old daughter when I received the case. She had lived in the home with them, as she had a debilitating illness. I called Mrs. Maxwell and she confidently stated that she did not need any assistance. She insisted that her husband's insurance would cover everything, as he had retired from a government position. I knew that was not the case, but I did not argue with her.

"Call me back in a couple of weeks, if you want," she stated.

Before the couple of weeks had passed, her son, Cameron, called me to make an appointment for a home visit. I told him that I had spoken to his mother and that she had denied needing any help.

He exclaimed, "I need help! My sister died two weeks ago, then my brother committed suicide the following week, and I am the only child left. I cannot do this by myself!"

"Oh!" I said.

He and I scheduled the home visit for the upcoming Tuesday. That day was a Friday. I got to Mrs. Maxwell's home and Cameron greeted me at the door.

I introduced myself to Mrs. Maxwell and Cameron said, "Oh, you don't know that my father is in the hospital?"

I asked, "What happened?!" as I knew that he was home just a few days before.

Cameron explained that his father's blood sugar dropped, and he had some other issues. So, I suggested to Cameron and Mrs. Maxwell that I could open her case, since I was already there.

"NO, I do not need any help!" she bellowed.

Cameron stated, "But, Ma, I need help!"

She insisted, "Your father and I are still together. We are STILL married!"

"That's not the point, Ma."

Cameron explained that his sister passed away and he had to make the funeral arrangements for her.

"Her bed is still in the room," he said, as he pointed down the hallway.

I turned my head to look and saw the hospital bed. The day of his sister's funeral, his brother committed suicide in his parents' home. The brother had not shown up for his sister's funeral. When they got home, Cameron went down to the basement and unfortunately found his brother. Cameron's problem was that he could not continue to do everything by himself, as well as take care of his parents. He had a full-time job, and he was sickly too. I explained the services that Mrs. Maxwell could receive, but nothing I nor Cameron said could convince her to accept them. I left without opening the case. However, I could not leave Mrs. Maxwell in limbo. I made sure that I called her once a week or so. As the holidays approached, I called to check on her and told her that I would call her when I returned from my mini Thanksgiving vacation.

Upon my return, there was a message from the agency who referred Mrs. Maxwell's case to me, letting me know that Mr. Maxwell had passed away. I quietly shed a tear at my desk because I had no idea what I was going to say to Cameron and Mrs. Maxwell. This case was taking a lot out of me, so imagine what it was doing to them. After I regained my composure, I called Cameron to express my condolences.

Astonished, I asked, "What happened?"

Cameron said, "I don't know. I would try to speak to or visit my father at least every other day, and he seemed to be in good spirits. Then, the nurse called one morning and said, 'Y our father did not wake up.'"

Mr. Maxwell was 96, and I guess the stress of losing two of his children was too much for him. I called Mrs. Maxwell and asked her if I could visit that week. She said I could. She had begun to trust me and we had established a relationship. I honestly do not remember what I said to her upon my arrival, other than, "I am sorry!" It seemed as though she was in denial. Her and Mr. Maxwell had been married for over 60 years!

I looked around the room, viewing some piles of mail, and asked her if she minded if I opened some of it. "Sure," she said. In reviewing the mail, of course I saw that every bill was overdue—phone bill, electric bill, and school and property taxes. There were also requests for her son's death certificate. I expressed to her that the taxes on her house MUST be paid so that she would not lose the house, and she asked, "Who does that?" I thought to

myself, *Oh my !* She had never written a check because her husband paid all of the bills.

I stated, "If you have a checkbook, I can show you how to write out a check, and then I will drop off your payment at the tax office."

She pointed to the piano seat, where I knew by now that all of the important papers were kept. I retrieved the checkbook and proceeded to show her how to write a check. The job had certainly taught me patience and tolerance; Mrs. Maxwell could very well be me one day. I took the check to the tax office and returned with the receipt. I told her of my plan to pay her school taxes next. That office was not as close as the property tax office. We would conquer one thing at a time.

I would visit her on a weekly basis. Not just to pay her bills, but for support. Then, I received a call from one of her family members reporting that Cameron had a massive stroke and was in the hospital. *My God*, I thought. The weekly visits continued, attempting to get her affairs in order. I would often bring her one of her favorites, a Kentucky Fried Chicken meal. Upon opening more mail, there were now requests for her husband's death certificate. I asked her for the death certificates and she said that she did not have them. I figured that Cameron had them, but he was still in rehab and unable to speak. I indicated that the next week we would work on getting them. Well, next week never came because Mrs. Maxwell had to be admitted into the hospital for a surgical procedure. *This can't be happening*, I said to myself. I now began to visit Mrs. Maxwell in rehab. Knowing

what she endured, I did not want to leave her stranded. Sure, the rules state that the rehab's social worker would now take over the case, but I wanted to ensure that she had a smooth transition.

Over time, I became so busy with my caseload that I realized I had not visited Mrs. Maxwell in almost two months. I felt guilty. Bereavement is agonizing. Soul-wrenching. It was good if she had a friend. I went to the rehab, and she was elated to see me. She had been in there for months. The rehab was reluctant to discharge her because she had not answered the safety questions well enough. I sat with her for a few minutes, making small talk. I asked her how Cameron was. She shocked me by saying, "Cameron died." It felt like someone had punched me in the stomach. I asked what happened to Cameron and Mrs. Maxwell explained that while he was in rehab, he stepped on something, and they eventually had to amputate his leg. He started acting strange, trying to pull out his IV s.

"He was just tired," she stated.

I hugged her and expressed my condolences. In one year, Mrs. Maxwell had lost her entire immediate family. It was too much pain for one person to bear. I empathized with her, and her losses affected me as well.

My mission now was definitely to get Mrs. Maxwell back into her home, with homecare. She would often say to me that she wanted to live her last days at home. I certainly understood, but it was lil ole' me against the nursing home. My speaking to the facility's social worker did not do anything. By now, she had been a patient

for more months than her insurance allowed, so she was a captive of the nursing home, spinning around in the Medicaid matrix.

Months passed. I had changed jobs, since I received an offer to work at the same nursing home that Mrs. Maxwell was in. I went to her floor one day to check on her and she was gone! I was told that she moved to an assisted living facility in the next county, near the residence of an extended family member. I was now left to forever wonder about Mrs. Maxwell's recovery, and I hoped that she would persevere.

What would I have done differently in regard to that case? I probably would not have gotten my emotions involved. Nonetheless, what human being could not have? You have to treat people as though they are the ones who will give you your last drink of water.

The personal and professional development skills that assisted me during that difficult time were communication and integrity. I would tell my younger self to, invariably, do the right thing. ALWAYS help others, if possible, because God may be answering someone else's prayer through you. Sure, I could have gone to my supervisor and roared that this case was overwhelming me, but would Mrs. Maxwell and Cameron have gotten the quality care that I provided from a different case manager? And, it was not about me, it was about them. That is not to say that sometimes it won't be about you. You be the judge, but judge fairly. Do not be self-centered. But know that, occasionally, you must be a little selfish if it is for your betterment or mental health.

Another piece of advice I would give to my younger self is: if different people keep giving you the same constructive criticism, maybe it is time to start listening.

Chapter Eleven
HOW THE F*** DID I GET HERE?
Deidre Hudson

Deidre Hudson is on a never-ending quest to live the best life possible. She is an avid proponent of lifelong learning, individual empowerment, and the art of authenticity. As a marketer that has worked with leading consumer and B2B brands, she is able to combine her avid interests of creative expression and understanding the psychology of the human mind. Deidre makes her home in New York City.

To connect, email her at deidre@greysneaker.com

"How the f*** did I get here?" I asked as I sat on an overstuffed green chair in the office of a psychiatrist one evening in early fall. For some reason, he didn't seem surprised to see me. I was actually under his care several years prior when I needed help sorting out some family issues, but abruptly ended our sessions as he got too close to uncovering the true source of my predicament. It was as if his sixth Spidey shrink sense knew we had unfinished business. In retrospect, I could almost hear him saying in the Terminator voice, "You'll be back."

"Where is here?" he asked.

"Here" was The Land of Angst and Fear. A place and space where I was so afraid of making a mistake that I felt trapped and stagnant. Where I was simultaneously

overwhelmed yet unimpressed by the routine that had become my life.

I used to be fearless. A non-conformist. If I wanted to do something, I did it. I never questioned whether I could or not. In fact, I would sooner think, *Why can't I?* than be shut out from trying new things or exploring new adventures. But somewhere, somehow, things changed. I became anxious, and full of sadness and self-doubt. I questioned my every move. My head was full and bursting with thoughts that I could neither control nor decipher. I couldn't sleep at night and struggled to get out of bed in the morning. Sometimes, I wanted to just disappear.

For the most part, things looked fine from the outside. I had my health, a great career in marketing, and a beautiful family. But on the inside, things were crumbling, and I didn't know why. Luckily, I started hyperventilating with some frightening degree of regularity and decided to see a pulmonologist. He was, in my opinion, a douchebag. Instead of, oh, I don't know . . . maybe running some tests . . . he advised me to see a psychiatrist, claiming there was nothing physically wrong with me. Of course, he was wrong, and a more qualified doctor subsequently uncovered the myriad of allergies that were physically causing my breathing problems. I did however take his advice. I took a deep breath, picked up the phone, and made an appointment with my former therapist.

Before I did, however, I decided that I was going to fully commit to the process this time and figure this stuff

out once and for all. No matter how uncomfortable the conversations became or how deeply we probed, I wanted the time-traveled mirror held up to my face. I wanted to understand why I felt like I was living on autopilot. Why I was sometimes paralyzed with fear. Why I was not living my best life.

I knew it would be difficult. I mean, really difficult. Who wants to spend 50 minutes every week talking about all the mistakes they've made and opening up old wounds? Not me! Wasn't that why I left therapy the first time? But I also knew it would be worth the effort; if I could just figure this out once and for all, I could take these hard-won lessons with me into the future. I could release some space in my mind and stop being a spectator in my life. So, I went on the journey and finally figured out what I needed to do. I needed to reclaim my power.

There was a point where I started to relinquish control over the decision-making in my life. I stopped deciding. I became the passenger instead of the driver. I went with the flow and started letting things happen instead of selecting the things that I wanted to occur. I accepted what I was offered instead of demanding what I needed. I call it living in The Land of "Might as Well." I remember hearing that phrase when I was deciding on what would become a major event in my life. It was in that moment, in that slice of time when I started accepting "might as well" as an option, that I started allowing myself to settle for less than I deserved.

Here's an example of this type of thinking:

You've been doing it this way for so long you might as well continue.

You've been working at this job for so long you might as well keep it.

You've been in this relationship for so long you might as well stay.

See what I mean? Where does this type of thinking get you? It lands you on the couch of a shrink in Forest Hills asking, "How the f*** did I get here?"

I'd love to get into my time machine and go back to that pivotal moment with my younger self where this stream of unconscious living began and scream, "Don't do it! Take a stand! 'Might as well' is not an option!" But of course, that is impossible. What is possible, however, is the future and learning from the past. Now, when I even come close to veering toward "might as well" as the answer to anything, I experience such a strong reaction in my body that I practically run in the other direction. Which led me to lesson number one: I needed to trust my gifts.

I was raised to be a good girl. Obedient. Respectful. Color inside the lines. And I was. I liked having rules and following a structure. And I did it well. I received good grades in school and didn't cause trouble at home. I did as I was told. Until I went away to college. But that's another story. What I realized is that although I was raised to be obedient, I was not raised to be confident. I

was not brought up to trust in my judgment, develop my own viewpoint, recognize my gifts, and believe in myself enough to use them.

The fearlessness that I experienced in my 20's was really an act of rebellion against the regimented thinking of my childhood. *Why can't I?!* became my internal mantra because for so long I had heard that I couldn't, or that I shouldn't, or some other negation when I expressed a desire for something other than what I was told I could or should do.

Every time my wrist was (metaphorically) slapped, or when I was ridiculed for expressing an emotion or a desire, I learned that my instincts did not matter. That I was incapable of knowing what I wanted and someone else would always have a better idea of what was right for me.

What I have learned, however, is that my instincts are the voice of my gifts and will guide me to who I am supposed to be. I am creative. I am intuitive. I have a high degree of emotional intelligence. Those are my gifts. I see things differently, I feel things differently, and I experience people in a different way.

In my chosen profession of marketing, I now nurture and draw on those gifts on a regular basis. A key part of my role is leading a team, and it is a responsibility that I take very seriously because of the impact I have on the lives of other people. Bringing on new members is especially important as it affects the existing team dynamics. A wrong choice can cause all hell to break loose. While working for a multibillion-dollar global fintech

company, I was part of a team that was responsible for bringing on a new member in a pivotal role. Let's call her Amanda. Due to scheduling issues, I interviewed Amanda on the phone during the process but was unable to meet her in person. I told myself that it was no big deal. Everyone else seemed to be satisfied so why upset the apple cart? Well, walking into the large, bustling lobby of my office building on the morning Amanda was scheduled to start, I saw a young woman at the security desk. She looked fine—nothing discernibly out of order. But my first thought was, *Oh no! I hope that's nother.* It was. Amanda lasted in that position for exactly three months.

My visceral reaction to her was so swift and strong that I knew something was off, like a faint odor in the air or a piece of clothing that just does not fit. And you know what? I was right. I can't explain it, but I've learned that this is just an ability that I have and instead of denying it or trying to dismiss it, I accept it as my gift. I rely on it, I leverage it, and I embrace it. Now, to perhaps my most important lesson: I needed to forget about O.P.T.

Yes, you have to be a certain age to recognize lyrics from the song "O.P.P." recorded by 90's hip hop group Naughty by Nature. But while being down with O.P.P. may have been fun in your 20's, caring about O.P.T.—Other People's Thoughts—in your 50's is not.

There is a reason stress is often called the silent killer. The physiological reaction the body has to stress is serious. When your body senses fear, it immediately goes into fight or flight mode. Adrenaline and cortisol

are released into your bloodstream. Your heart rate increases, your blood pressure rises, and increased glucose is delivered into your system. Over time, depression, weight gain, skin problems, and other more serious conditions can occur. Stress is your body being in a constant state of fight or flight.

I realized that one of the most constant sources of stress for me was O.P.T., or more accurately, what I thought Other People were thinking about me. If I spoke out at work, I would experience a sharp pang of fear that "they" thought I was lacking the experience or expertise to offer a credible opinion. If I made a mistake on a report or miscalculated a figure, there was that pang again. If I wore a certain outfit or styled my hair in a particular way, I would immediately assess how my choices might be perceived by Other People.

And I know we all (or most of us anyway) have some desire to fit in, to be taken seriously, and to be thought of favorably by our peers. So, I am not referring to the cursory level of interest we have in how we are perceived by others. The level of anxiety I would experience was panic attack level. It was mind-numbing, intense, and sharp, complete with heart palpitations and a deep foreboding.

After identifying this fear, I learned to take a different approach. By taking a step back and repositioning my focus, I instead approached it from a place of curiosity, and started to dissect it with pragmatic precision.

I questioned the identity of this mysterious group of Other People. Who exactly were they? Who comprised this pack of naysayers that I was always so worried

about? And when I was concerned about what "they" thought, did "they" have a name? A face? If so, I could engage "them" in a direct conversation and confront any issues head-on. If I made a mistake at work, I could address it directly. If I expressed a vision, I could solicit feedback. And if "they" had a problem with my hair or dress . . . well, watch me as I twirl on by! By understanding that I had the power to confront or ignore, I was able to demystify this amorphous group of Other People and minimize the space and place they were occupying in my brain. I realized that I can no more control the thoughts of other people than I can conjure up purple elephants. And the reality is, I don't need to. I don't need to worry about O.P.T. I need to worry about my own thoughts. Because it is through my thoughts that I can create and control my destiny.

The quickest way to ruin a dish is to have too many cooks in the kitchen. Thanksgiving and Christmas were big holidays in my family, and we looked forward to my mother's roast turkey and giblet gravy all year. But as my mother aged and could no longer cook a full holiday meal, she took on a supervisory role. And supervise she did. As my sisters and I worked together in the family kitchen, preparing the dinner we would all consume the next day, we were required to follow her instructions to perfection. She had honed those ingredients and proportions over decades, and we were not allowed to mess with the formula by trying to put our imprints on her creations.

I believe we are supposed to be a blessing to other people. But it is impossible to fulfill our true purpose and become a blessing if our individual recipes are muddled.

The sum of what I have learned, what my younger self retaught me and what my future self will bring on our journey, is that we have much more power than we think. Nothing is written in stone and there is no invisible magic thread pulling us through life by our belly button. If we are conscious, we have a choice. The stories that we tell ourselves, the inner worlds that we create, are all up to us. And our external worlds are a direct reflection of the thoughts and feelings we stitch together internally. It all begins with a thought. So, if you can have negative thoughts that are not creating the outcomes you want, you can create new ones. We truly do have the power to create the destiny we desire.

Chapter Twelve
THE EPIPHANY IN ROOM 122
Tameko Patterson, PMP

Tameko Patterson is a certified project manager and business process improvement expert. For more than 20 years, she has managed countless multi-million-dollar projects across the banking, finance, securities, and biopharmaceutical industries. In her spare time, Tameko serves in a leadership capacity for multiple organizations including the Stroudsburg Area School Board, East Stroudsburg University Council of Trustees, and the Monroe County NAACP, to name a few.

Tameko leads initiatives; participates in discussions on issues related to diversity, equity, and inclusion; and works tirelessly to fight against racism, bigotry, and hatred. She is often sought-after to lend her expertise to the development of projects and programs focused on improving the quality of life for black, brown, and marginalized people. She has received numerous awards and citations for her role as a servant-leader.

To connect, email her at tbpatterson817@gmail.com

I felt like I was dying. The pain radiated from my left shoulder to my chest. It was excruciating. So much so that it woke me from a sound sleep. While lying on my back, I lifted my head slightly to steal a glance at the clock on my dresser across the room. The numbers seemed to glower from the digital display. 3:34 a.m. I

slowly reached over to the nightstand with my right hand to pick up my cell phone. I immediately started to worry because I recalled reading somewhere that arm and shoulder pain were symptoms associated with a heart attack.

With my cell phone in my hand, I was very deliberate about how I maneuvered my body to lie back down in a position that would not exacerbate the pain. My king-sized bed, which usually served as a respite, provided no relief at all. Every slight movement of my left arm caused the pain to become inflamed. I labored with my right hand to open the Google app on my phone. I took a deep breath and held it momentarily while typing "heart attack symptoms." I exhaled gently and then pressed enter.

I wasn't quite ready to see the results of my internet diagnosis, so I rested the phone on my abdomen and began to pray silently. "Dear God, please don't let this be a heart attack. I know there's no way you brought me to this point in my life to have it all end now." I waited a few moments for God to respond, but the only sound I heard was the soft snoring coming from the other side of my bed.

Without looking at the results, I placed the phone back on my nightstand, face down. I sat up carefully and quietly as to not put any pressure on my left side, or to awaken anyone else. I slowly staggered to the bathroom medicine cabinet to look for something, ANYTHING to ease the pain. I fumbled in the (mostly) dark and strained desperately to see. The only light visible was coming from

the moon shining through the skylight above. Eventually, I discovered a bottle of Motrin.

Using only my right hand, I opened the bottle and poured out two brown caplets. I closed the bottle, placed it back in the medicine cabinet, and made my way back to my bed. I was grateful that I always keep a bottle of water on my nightstand because I wouldn't have been able to make it downstairs to the kitchen.

I sat on the edge of the bed, put the two caplets into my mouth, and took a swig of water. The pain was so relentless by this point that I started feeling lightheaded and nauseous. I paused for a few seconds then reached over to pick up my phone to see what "Dr. Google" had to say about my symptoms.

The screen glared back at me: "Heart attack. Also called: myocardial infarction." There were numerous symptoms listed including all that I was currently experiencing: arm or shoulder pain, chest pain, lightheadedness, and nausea. For some odd reason, my mind wandered to Fred Sanford from the 1970's TV sitcom *Sanford and Son*. *I'm comin', Elizabeth*, I thought to myself.

Understanding the possibility of what could be wrong with me, I started thinking about my life. I thought about the poem, "The Dash," by Linda Ellis, that I'd heard recited and had even recited myself at numerous homegoing services. In the poem, the dash is defined as all the time you spent alive on Earth. At the end the writer asks, "would you be proud of the things they say about how you lived your dash?" once you're gone? I sat and

pondered the question for a few moments. If I were to die today, how *would* people say I lived my dash?

I looked up at the clock again. It was now 4:47 a.m. The pain had subsided a little, but the concern did not. I closed my eyes and began to repeat an affirmation I memorized from a book I'd read by Iyanla Vanzant (I don't recall the title). "I trust that God will provide everything I need to live life fully, peacefully, and abundantly." I recited that phrase in my head over and over until I fell asleep. The alarm on my phone woke me up. It was 7:30 a.m. I was still in pain.

The logical thing would have been to go to the doctor right away. I managed to convince myself, however, that I had too many people depending on me and too many important things to take care of before I could "waste time" sitting in the doctor's office. So, I mustered up all the strength I could manage to eat breakfast, shower, dress, and start my busy day. I took three more Motrin caplets for good measure and placed the bottle into my purse, just in case. The clock on my stove read 8:43 a.m. as I headed out the door.

I went about my day, trying to ignore the pain as best I could. I led a meeting, went grocery shopping, and picked up family from the airport. When I completed all my obligatory tasks, it was 4:22 p.m. By that time, of course, the Motrin had worn off completely and my shoulder was throbbing. I had also started to feel lightheaded and nauseous again. "It's time to stop playing around and get checked out," I said aloud to myself. I arrived in front of the urgent care office at 5:53 p.m.

I was elated when I walked into Stroudsburg Urgent Care to find no one in the waiting room. I walked up to the reception desk and added my name to the bottom of the sign-in sheet. A chubby, young Latino man sitting behind the counter flashed a big smile and asked, "How can we help you today?" I couldn't help but notice that the gold name tag on his light blue scrubs read "Jesus." I managed to chuckle to myself through the pain. I explained to Jesus that I was having really bad pain in my left shoulder and chest. He stood up quickly and said, "Wait one moment, Ma'am." Within a minute, Jesus had returned to the counter with a nurse. She asked me a few questions about where I felt the pain and when it started and then politely said, "I'm sorry, but we can't treat you. You need to go to the hospital. Is there someone here with you?" I lowered my head and responded no and that I'd be fine. Fortunately, the hospital was literally less than a quarter mile down the road.

When I walked into the emergency room at St. Joseph's Hospital, there was only one other person in the waiting room, thank goodness. I walked up to the registration desk. A pretty, brown-skinned girl with long, brown sisterlocks looked up at me through the glass. "What brings you in to see us?" she asked. I explained my symptoms to her. She confirmed my name and information on the computer and then gave me my very own personalized hospital bracelet. She told me to have a seat in the waiting room and someone would call me shortly. Before I could decide where to sit, I heard my name.

An older, portly woman (I think she said her name was Barbara) led me back to Room 122 where various medical staff asked me a myriad of questions while poking, prodding, and pricking me with needles. Within five minutes of arriving in Room 122, I'd been stripped of my clothing and wore nothing but a hospital gown and my undies. Fifteen minutes later, the team had taken my temperature and blood samples. They also managed to take my blood pressure, insert an IV into my arm, and connect me to an EKG monitor, all in record time. After they discerned that I wasn't going to die immediately (my words, not theirs), the nurse gave me the emergency call button (which doubled as a remote control and speaker for the television), and they all left me alone while waiting for the test results. *I'm not coming today after all Elizabeth*, I thought to myself. As I lay in the hospital bed, listening to the constant beeping of the EKG monitor and looking at the IV bag, I started thinking about my dash again. If I were to die tomorrow, what would people say about how I'd lived my life?

I am a daughter, sister, aunt, wife, mother, friend, and servant-leader. I've spent much of my adult life working for corporate America by day, while rallying for equity and civil rights by night.

I was born and raised in Queens, New York, but I've also made a home in Atlanta, Georgia, and Brooklyn, New York, before finally settling in Small Town, USA (better known as the Poconos, Pennsylvania), where I've lived since 2009. When I lived in New York City, I always managed to keep myself busy and engaged. I worked as

an information technology project manager for a Fortune 500 company, served as PTA president, and ran my own music entertainment magazine, all while raising a family. I always knew I had an affinity for helping people, but it wasn't until after moving to the Poconos that I was finally able to live out my passion of serving the underserved.

My dedication to and passion for serving have enabled me to become a trailblazer in my own right. I was the first person of color elected to the Stroudsburg School Board, and subsequently the first person of color elected as the board president. I was also the first person of color elected to the Monroe Career and Technical Institute's Joint Operating Committee, and most recently the first black woman appointed by the Pennsylvania Governor to East Stroudsburg University's Council of Trustees.

Even though I have been content with the work I do in my community, people close to me have always had ideas about what they thought I should be doing. Community service was never one of them. If I had a dollar for every time someone said "you should" to me, I'd now be the proud owner of an island somewhere in the Caribbean. While my friends and family were out chasing a dollar and the ever-elusive American Dream, I was busy searching for ways to ensure diversity, equity, and inclusion for marginalized peoples.

As I reflect on the path that God chose for me to follow, I would be remiss if I didn't share the lessons I've learned along the way.

I've learned not to let other people define what success looks like for me. You don't have to be a doctor, lawyer, or entrepreneur to be successful. My non-profit leadership roles have afforded me more opportunities in terms of networking and personal growth than I would have been able to achieve otherwise.

As a person of color, it's important to get a seat at the table, but the seat may not be comfortable. There have been many times when I have been the only woman or the only person of color at the table. I wish that I could say I always brought my authentic self to the discussion, but I didn't. Most of the time, I engaged in code switching. I mastered the technique so well that I adopted Chaka Khan's "I'm Every Woman" as my theme song. I learned that whatever I did or didn't do, however I acted or failed to act, I was making an impression that could potentially impact how black women who were permitted to sit at the table with or after me would be perceived.

The saying goes, "If you want something done, ask a busy person." Being an empath has made it hard for me to say no. People have often come to me for help with projects and initiatives. After burning myself out one time too many, I've learned to not waste my precious time doing anything that doesn't feed my spirit.

Lying in the hospital bed served as a wake-up call. It was a clear reminder of the importance of practicing self-care. Admittedly, this is something that I've never been good at. I often fill up my time serving and taking care of others (family, friends, pets, and strangers), and

leave no time or energy to take care of me. I've learned the hard way that I'm no good to others if I'm not first good to myself.

I used to buy into the myth that you must be filthy rich to be happy. I've learned that to be an utter and complete lie. Happiness cannot be bought. I recall some of the happiest times of my life occurred when I had little to no money.

Music has special healing powers. I've learned that when all else fails, just dance! I remember dancing at the Garage back in the mid-1980's and experiencing feelings of euphoria. Anytime I needed a quick pick me up, I put on my headphones and listened to the soothing sounds of some of my favorite artists like Fertile Ground or Amp Fiddler and danced like no one was watching.

And probably the most important lesson of all, I've learned that only I can truly calculate the level of my success. While I remain humble, as I know the work I do is for and through God, the contributions I have made in, to, and for my community are innumerable and immeasurable. I am beyond grateful for the opportunities I've been given to serve.

Oh, yeah, about my diagnosis . . . an x-ray showed that I had a rotator cuff tear. So, God willing, I'll be here to serve for a while longer.

Chapter Thirteen
IT'S NOT ONE THING BUT EVERYTHING THAT DEFINES YOU
Michaela Renee Johnson

Michaela Renee Johnson is a psychotherapist, life coach, and forever learner who grew up in rural Sierra Nevada without running water or electricity. She is an avid adventurer, having traveled to over 20 countries, and a self-proclaimed boho mom who loves all things metaphysical as well as poetic quotes. She is a Sagittarius and an ocean lover who, in her spare time, often hikes, does yoga, gardens, golfs, and reads. She lives with her husband and young son in Northern California.

Michaela has a bachelor of arts in journalism communications and a master of arts in psychology. She is a California state licensed psychotherapist.

Learn more at www.michaelarenee.com

I remember the day clearly. I sat in the makeshift shed my parents had built. There was snow on the ground outside. I was curled up on the plywood floor because the propane space heater was on. There was still enough light of day to write. We lived in the rural Sierra Nevada without electricity or running water. It was my parent's choice, not mine. As a teenager, I had many days where I was outraged with our circumstances. Little did I know, those moments were the concrete pavers that would

lead me to becoming a happiness expert interviewed on international news programs, radio shows, and podcasts. We didn't have much money, but pen and paper are cheap. Writing was what I did then to heal my heart of sadness, and writing is what I do today.

As a young person, I held the belief that my life was starting out on the wrong side of the spoon. I thought that I'd never be able to scoop up all the great things life had to offer unless I worked harder than everyone else. My parents were too poor to pay for me to go to college, and they were too wealthy for me to get a scholarship. It didn't feel like they were very wealthy to me as we sat by candlelight eating Top Ramen for yet another night and using a porta potty in the yard. I was angry at the system. I thought I deserved as much as the next person. I learned young that your birth certificate doesn't come with a list of givens and that life is what you make of it. Although I didn't know it yet, I was building grit.

Older people would say, "I see a spark in you, you'll do great things." Little did I know that spark is what you create when you are tired of being cold. Many of us still shiver waiting for someone to light the fire for us.

I remember sitting in a journalism class in high school with my favorite teacher of all time. He often played the Tracy Chapman *Fast Car* album. Something about the words to "Talkin' 'Bout a Revolution," "poor people gonna rise up, and take what's theirs," subconsciously hummed as the undertone to my outrage. But rather than embracing a victim mentality that something was owed to me, I took that to mean I needed to

work hard to create what I wanted in life. Unlike most teachers, he didn't ask us what we wanted to be when we grew up, he asked what we were excited about in life. Where most adults made it seem like you pick something to do with your life, he allowed us to think outside the proverbial box. What sorts of things filled our bellies with fire? What sorts of things did we want to fight hard for in life? I think this is where a lot of young people today are steered wrong. They are asked to decide their future by the time they are eighteen years old and then expected to make every decision moving forward to advance in that direction. The ideology is: pick what you want to be, chase it, and then you'll be happy.

That thinking has set up a society of people who are anxious to get "there" rather than excited to enjoy the journey. The letdowns happen when the destination doesn't look quite like we'd created it in our mind.

In college, I realized that one thing I learned from my upbringing is that life is about experience. The notion of "achieving happiness" is not realistic, at least not for an extended period of time.

Our culture has taught us that happiness is something that we can all have. As if it's there, and once we catch it, it's ours forever. This could not be farther from the truth. There is always something that's trying to steal your happy factor. Happiness is a constant reset. This is why so many people are brought to their knees in the face of adversity today. We've built glass houses. So, when our glass walls are shattered, we find ourselves having a difficult time getting back up. We get the job that we want, the

house that we want, the spouse that we want, the kids that we want, and then we wonder why we aren't happy. We wonder how we'll ever make it through the challenging things that happen in life and the inevitable losses of all that we created.

Call it a stroke of goodish bad luck, but I couldn't afford a glass houses. I had to roll with whatever opportunity came up in life, whether it was ideal or not. I could experience all that life had to offer. I could sit with unhappiness and failure for a moment, have a conversation with it, then move forward. In my thirties, I realized I didn't need to impress anyone with my achievements. I just needed to show up as my authentic self, the one who could speak her truth with grace. I also realized that the only failures I had were when I missed the experience. Some of the greatest lessons I learned came from my failures and I always walked away from them stronger.

People who can tap into their resilient nature and dig deep to find a brighter outlook in spite of life's setbacks are set apart from those who can't. That's the thing about humans, we are hardwired to solve problems. Humans thrive when they are uncomfortable and the greatest inventions blossom in this space. Here are two really enlightening things about failure—one person's failure is another person's success and failure is in the eye of the beholder. My parents never saw living the way we did as a failure; they saw it as a fresh start to building a better life.

When you come upon an opportunity in life, know that it is okay to try, and even better to fail when you

worked passionately and endlessly on reaching your dreams and goals. The grit that you gain in your most trying times is what builds your resiliency as you continue in life. On the precipice of every perceived failure is the view to your biggest successes. Rarely do we make the changes we need to make—the ones that advance us the most—when we are comfortable. Don't spend your life working toward one thing; embrace the journey, lavish in the experiences, relish in the failures, be grateful for opportunity, and by all means, cheer for your successes.

After hundreds of hours earning a master's degree in psychology and hundreds of hours learning to be a psychotherapist, which included getting counseling of my own, I thought I fully understood the inner workings of the human mind. I already knew from my upbringing that resilience and grit were the key ingredients to helping people move through grief, loss, anger, and a slew of labels like anxiety, depression, and PTSD. I also believed that it was my mission to "help people gain the clarity they need to live their best life," which was something I touted on my online profile from 2011 until 2018. But I quickly began to realize a critical component was missing. It wasn't enough to say that happiness is a constant reset, and that you need to be resilient and bounce back quickly in spite of life's setbacks. It wasn't enough to say living with clarity would help you show up more authentically in your life and experience more happiness. Something was missing.

Brené Brown's Ted Talk, "The Power of Vulnerability," came out when I was interning as a therapist. Over the years, I've directed hundreds of people, via my counseling couch and podcast, to her YouTube page to learn about being vulnerable and living a courageous, daring life in order to move forward and let go of shame. And I wholeheartedly agreed with all of that.

But that wasn't enough either. Something was still missing. I realized that it didn't matter how much clarity people had, or how authentically they showed up, or how much grit and resilience they threw at tough situations, people needed to BE THEMSELVES. They needed to be able to show up in whatever way they looked that day and be okay with that. I needed to learn a little something about that too.

That was when I realized that the key to a happy life is speaking your truth with grace. Too often, we answer a question with how we think other people want us to respond and we make decisions in our lives that don't align or connect with our inner truth. We live authentically for everyone else and the seeds of resentment start to blossom. A life well-lived is one where we can show up as we are and share that with the world, unapologetically.

It's the mom who gets asked to pick up someone else's kid from school every week, who feels overwhelmed by it, but knows that she's "just" a stay-at-home mom and Julie works all day. Her guilt kicks in and she says, "Sure," not wanting to create conflict for Julie; thereby, creating conflict for her inner truth and her outward expression.

It's that mom finally having the voice to say, "It's not going to work today, Julie," and leaving it at that.

So many of my clients start speaking their truth by leading with, "I'm sorry, but . . . " Leading with I'm sorry creates a narrative that you don't deserve to speak your truth, that you need to apologize for being you, straight out the gate.

Clients will often ask me, "But isn't apologizing kind and good?" My answer, "It depends." Did you step on someone's toe in the grocery store? If so, an apology is probably appropriate for a few reasons. One, you likely didn't mean to do it. And two, you probably caused direct pain to another person.

Unfortunately, apologizing for how we feel has become the norm in our society. There are many situations in relationships where there may be an opportunity to apologize for your part. However, I always caution my clients that there are very few scenarios where one person owns 100 percent responsibility for an event.

I often see couples in patterns of behavior where a fight ensues and one person gets a little crazier than the other. In the end, the crazier one always ends up apologizing. My question to that person is, "How does that feel in your belly?" The answer is almost always, "Not good." It doesn't feel good because we know in our hearts that we are not the exclusive cause of the events. This is where it can be good to practice apologizing only for your part.

Some clients panic at the idea of telling their in-laws they can't make it over for dinner, wanting to start the

conversation with, "I'm sorry but we . . ." I like to pause people in these situations and show them how they just smacked their inner truth in the face. They know that given all the other things happening that week, the burden would be too much; yet, they are apologizing for their reality, their intuition. Instead, I encourage them to try saying, "While we'd really love to see you, it's not going to work out this week. We've got a lot going on." This phrasing removes the conflictual apology and expresses the situation without apologizing.

The biggest struggle I see is that when people first start learning how to speak their truth, sometimes they forget the final component—grace. Showing up in our relationships in an ugly way leads to discontent. If you can't speak your truth in a kind and loving way, it's probably best that you dig a little deeper as to why before saying it aloud. You aren't serving anyone in your life, or yourself, by spouting off a bunch of unkind realities. If your anger is overwhelming toward a situation or someone, it's on you to work through that. If you are triggered, it's not the other person's fault; there's a discomfort deep within you that you need to sort through. I often tell clients that it's not my job to create a steady boat for you; my job is to empower you to face the stormy seas with your own paddle.

This is why one of my greatest lessons in life ended up being one of the greatest things I can offer the world. I learned the importance of us being responsible for ourselves, from the inside out. We should not rely on others to create a path for us to follow, but rather, we should

embrace the experience of becoming who we are without apologizing for the process of accepting and sharing our inner truths. Becoming all that we are meant to be means embracing the missteps right alongside the leaps.

There was a time I wrongly believed that I could achieve happiness via peace and contentment. I believed that by being me, gracefully, I would epitomize calm and create a life of ease. The trouble is, we are human. We are going to make missteps; we are going to feel irrational emotions; we are going to show up in less than kind ways; we are going to prioritize the wrong thing and make decisions that in hindsight were dangerous, toxic, or not well thought out. That is okay. It's okay to be a forever learner. It's okay to be human. The journey of becoming means acceptance of the good and the bad. It's our obligation to circle back, make amends, and speak our truth with grace.

It wasn't until I turned forty that I realized all of the wild and crazy things I'd attempted and the dead-end roads I'd traversed (only to find myself turning back or randomly bombing off the path all together) had led me to where I am now—a bestselling author, host of a top iTunes podcast, and a successful psychotherapist. If I were to hit pause on the replay of my life, I would see my anguish when something negative happened. It hurt, it didn't feel good, it was hard. But now I see clearly that those experiences helped to catapult me to the next place. It's not as if they all worked out beautifully and my failures were swept up in a dust pan. Sometimes it was overcoming the failure itself that led to the discovery.

Sometimes it was seeing someone else succeed at what I'd failed to do or given up on. But with 20/20 vision of the past, it wasn't one thing, it was everything that led me to where I am now. I know moving forward that the same will be true. That makes it easier to accept the space I'm in, sit with it, learn from it, and show up with gratitude.

Chapter Fourteen
REST WITHIN SUCCESS:
AN INTERCHANGING JOURNEY
Krystal L. Bailey

Krystal L. Bailey was born in Chicago, Illinois, and grew up on the south and east sides of Long Beach, California, where she earned degrees in liberal arts, communications, and counseling. She is the youngest of four and the only girl on her mother's side. Krystal has a wide variety of interests ranging from volunteering, traveling, and being a foodie, to modeling, and playing adaptive sports. Krystal now lives in the Bronx, New York, and works in rehabilitation counseling. When not writing, she lives her life to the best of her ability.

Learn more at
www.instagram.com/EverydayKrystal

In the world I live in, societal milestones are expected to be met. If they are not, then something is terribly wrong. What are societal milestones? Well, the simplest way to explain them is: developmental skills that are universally accepted and required of everyone to obtain and excel in (i.e., walking, talking, reading, writing, getting a driver's license, graduating, obtaining a career, marriage, children, etc.). However, imagine being born and having no expectations put on your life. I was born in the 1980's. It was a time when the life expectancy of people with disabilities was maybe that of a toddler. And if multiple

birth defects were present, a doctor would inform parents that the likelihood of survival was slim. Bluntly put, the infant would not survive. My mother was told just that. And on a winter day in Chicago, she began losing an enormous amount of blood due to hemorrhaging. I was birthed out of death; my mother flatlined as they removed me from her body via a C-section. While doctors fought to bring my mother back to the land of the living, they began the long journey of keeping me in the land of the living.

Though I wasn't necessarily expected to reach societal milestones, I did. And with each milestone I achieved, I praised (celebrated) then pushed on to the next one. I produced, praised, and pushed over and over again. There was no time to rest within the progress I was making. I had to continue the momentum, especially during my formative years. These concepts of survival in producing results, praising in gratitude, and pushing to the next goal along with the doubt of my life expectancy due to my disability motivated me. They attached to every fiber in my life, guided my journey, and became my blueprint for how to live. However, as years went by and I became wise, adjustments to the concepts were needed. I still needed to produce, praise, and push, but I had to remember to rest within success.

I was born with spina bifida (which is when the spine and spinal cord does not develop completely) and other birth defects. At three days old, I had my first surgery; my right kidney was removed due to complications. My first home was not in my mother's arms, it

was in the Newborn Intensive Care Unit (NICU) with dedicated nurses until my mother was strong enough to care for me to her full ability. We progressed together because there was much to learn about raising a child with multiple disabilities, but more importantly, I had much to learn about living with a disability. My mother learned about feeding tubes (i.e., inserting them and ensuring they remain barrier-free), and how to care for wounds, give shots, find inventive ways to administer unpleasant medications, and provide comfort during difficult recoveries after surgeries, all while teaching the same to me. My blueprint (produce, praise, push) was most effective during those early years. I was told what to do, I was shown what to do, and I did it. At the age of three, while non-disabled children were potty training, I learned how to catheterize myself. While non-disabled children went on vacation, I went to camps specifically for people with disabilities. While non-disabled children learned how to ride their bikes, I learned how to hop curbs and ride escalators. While non-disabled children were able to live, I learned how to survive. I produced, praised, and quickly pushed to the next milestone.

I continued putting my blueprint into practice. I was valedictorian of my eighth-grade class, I was playing wheelchair basketball and getting a lot of playing time as a first-time player, and I had some pretty amazing peers. But that all changed in my junior year of high school. I moved to California, reunited with my kindergarten peers, and became more interested in just living. I produced, barely. I praised my struggles, sometimes. But

the difference came in the push. I was so tired of push-
ing that I stopped. All I wanted to do was socialize and
be a "normal teenager," just like I saw on television.

So, I did. I went to football games, I went to formals,
and I ditched classes a lot. I experienced all of the things
I saw in teen movies of the 90's and 2000's and it was so
much fun, until it was time to graduate and I had no
postsecondary plans. My guidance counselor "discov-
ered" a scholarship specifically for students with disabil-
ities attending community college, and I was pushed to
apply and think about life after high school and beyond.
Though I did not desire to continue on with my educa-
tion initially, I enrolled in Long Beach City College and
majored in kinesiology, but changed to child develop-
ment, then early childhood education, then psychology,
and finally ended with communications. It was obvious
that being pushed to attend college was not beneficial. I
had to decide that I wanted it for myself. The blueprint
was reinforced, with heavy emphasis on produce and
push, once I transferred to a four-year university. I grad-
uated undergrad in six years because I made a choice
to experience it all, as much as possible. During those
years, I was inducted into an honor society; employed
as a research assistant, resident assistant, peer mentor,
and student ambassador; held leadership roles in stu-
dent government; and of course, I graduated. Then, for
the first time in a long time, I praised and enjoyed my
success. My mother planned a graduation party which
included not only her side of the family but also the pa-
ternal side of my family. I lived in the rest for a while

because resting within the success fueled my drive for the next push—graduate school.

I entered graduate school refreshed, renewed, and ready to obtain the skills I needed to be a self-sufficient adult. On May 15, 2010, I graduated magna cum laude with my master of science in rehabilitation counseling. Again, I produced, praised, and pushed toward my first employment opportunity and after graduating, I relocated to New York City. Within four months, I was employed. It was a happy time for me, but that happiness was short-lived due to my inability to rest within success. I just couldn't enjoy it. I had to keep moving, even if it was in directions I knew would not lead me to where I desired to be, even when my gut told me "Krystal, this is not for you," even with red flags waving everywhere.

By not fully resting, my health problems increased. By not fully resting, I started things I knew I didn't have the drive to complete. By not fully resting, I allowed other people to dictate my moves. By not fully resting, I found myself sabotaging my opportunities for advancement. By not fully resting, I found myself in unnecessary and unpleasant situations. By not fully resting, I stayed in situations and relationships past the expiration date. By not fully resting, I was doing a disservice to myself. I needed to learn to rest within success.

The year 2016 brought hard lessons. I was literally forced to rest, but not in success. I dislocated my hip and broke my femur. Out of all of the hospitalizations and surgeries I had, never had I broken a bone, so that pain and the road to recovery was different. I had always

been very active and able to move with speed and precision; however, due to that incident, my limitations had limitations. I could only be in my chair for a few hours at a time due to swelling. I had to change my diet because I was in too much pain to be physically active. I had to adjust to taking additional medications and suffering their side effects. I could not transfer from my wheelchair to my bed or toilet with ease anymore. And it took me triple the time to complete simple acts like bending down to pick something up off the floor or tying my shoelaces. I had never felt so physically disabled in my life, and I had to sit with the unpleasant feelings and thoughts and learn the lessons of self-preservation, self-motivation, self-worth, self-love, and self-care. Within the sadness, anger, and fear I was forced to experience, I finally had the opportunity to rest and listen to my body and myself.

I finally had the opportunity to evaluate what in my life brought me joy and progress, what brought me pain and stagnation, and what I had a passion for versus what I'm simply good at. But it was so hard. While I was enlightening myself to new aspects of my identity, I was also in mourning because I had my entire identity enveloped within a specific state of being, and within a second it all changed. The forced rest required me to sit with all of my pain and doubt and figure out how to transmute it into something positive; how to love all of me; how to live and not merely survive; how to grow at my own pace; and how to rest within success because all steps, big or small, are successes.

Chapter Fifteen
CAREER RESET: WHEN QUITTING ISN'T AN OPTION
Latasha M. Smith

Latasha M. Smith is the award-winning owner of Occasions Banquet and Catering Hall, the largest, longest running, black female-owned banquet and catering hall in New York. Known for creating stunning on-premise weddings and special events, she also owns Occasionally Yours which provides off-premise wedding and event coordination and decorating. Latasha is also a licensed wedding officiant, a student mentor and work-life trainer to many teenagers and York College alumnus, and the proud mother of two.

Latasha worked in business for her entire career, rising through various positions in corporate America while putting herself through college. In 1990, she earned her BS degree in business. Having finally found her niche in events, she immediately put her degree to work within her corporate job and entrepreneurial endeavors where she coordinated and implemented special programs, corporate training sessions, weddings, and social events. Latasha left corporate America in 1998 to open her own banquet hall. In 1999, Occasions was born.

Learn more at www.occasionsbanquethall.com

As an entrepreneur in event planning and hosting for 29 years, my decision to leave corporate America and own and operate my own banquet and catering hall left me simultaneously living both a dream and a nightmare. I opened during a time when NYC's catering hall business was extremely Caucasian-dominated and the food, ambiance, décor, and event details were all targeted toward Caucasian traditions and experiences. Most halls requiring catering offered foods that did not reflect the cuisine of African Americans, those from the Caribbean, or people of other ethnicities. Hall coordinators dropped mocking looks and snide comments when my non-white clients attempted to incorporate their foods or customs into their night's festivities. Halls would advise: "No one wants to eat the same foods they eat every day" and "That's not how classy weddings are done." Weddings or certain events are "supposed" to go a certain way otherwise you are "undignified."

The issues I experienced while planning my wedding in 1989 made me become a wedding planner. The issues I faced with my customers with catering halls made me dream of opening my own hall where I could provide ethnic people a chance to celebrate their special events the way *they* imagined while still keeping it classy of course.

My name is Latasha Smith and I am the owner of the largest, longest running, black female-owned banquet and catering hall in NYC. I've spent the last 29 years of my life growing and developing Occasions Banquet & Catering Hall and Occasionally Yours event

coordination. I have developed and conditioned many young men and women to be able to work and grow in their job choices and I continue to back community events.

In analyzing how I got here, I had to explore where I came from. After graduating from high school in 1984, I went straight to York College in Jamaica, Queens. While searching for a summer job, I realized that most positions required experience, even with a degree. So, I took a full-time job while I completed my full-time college studies. I worked for one of the most prestigious companies in the world at the time. It had everything. I called it "golden handcuffs" because we had numerous perks and amenities to keep us happy, but some of the departments had some of the worst people in charge of them. I worked in human resources. It was a large department with many sub-departments, most of which were run by women and men who acted like women. Much of HR management were catty, vindictive, plagiaristic, and just plain bitch-like. Oh, and let's not forget racist.

My first boss was a hard man which made him unfavorable to almost all that reported to him. But he was a mentor to me. He saw the shine peeping from my emerging diamond and continued to polish it. He consistently assigned me tasks above my level and pushed me to rise to the occasion. When increases and promotions came around, he made sure I was up for those. He sometimes had to fight for me and prove my qualifications and abilities because higher-ups would challenge and push him to hire or promote a lesser qualified white

person over me. My department was reorganized often and my boss was eventually terminated under one of the reorganizations.

I was transferred to another sub-department where my new boss was wonderful. She continued to polish my diamond. She was very supportive. She knew that I would get the job done no matter how many hours I had to stay, so she never had a problem when I needed time to pursue my outside endeavors. By this time, I had begun Occasionally Yours and sometimes things over-lapped.

Another reorganization disbanded my department and landed me smack dab in the cattiest part of HR. This was the beginning of my descent from corporate life. These bosses, unlike my first bosses, were ruthless and cut-throat. Instead of crediting me and rewarding me for my accomplishments, they would assign me tasks and when I excelled at them, they would quietly and secretly take credit for them. A coworker put me on to them. After that, I would monitor my bosses' files after I would complete a project and, sure enough, they would get salary bumps or promotions right afterwards. I could not dispute or fight because I was not supposed to know. Although I had access, I had no reason to be in their files. As life often goes, I had to tuck away my knowledge and bide my time until I could leave.

As luck would have it, yet another reorganization was going to outsource my department and they were offering packages. Yesss. I was awaiting my meeting to discuss my package when I, instead, got a different

meeting. My boss called me into her office to tell me that she had gone to the HR directors and explained to them that they would be remiss in letting me go as I had single-handedly created this program, spearheaded that policy change, and handled those operations. Suddenly, I did these things. This was the first time I got credit for them. They decided to offer me a job. I DIDN'T WANT NO DAMN JOB . . . I WANTED A PACKAGE! Then, I saw my out. They insulted me. They offered me, me, who had been there for almost 12 years with a college degree, a HR special projects position. Translation, "HR Shit Work." I would have to do different projects while sitting at the reception desk and buzzing people in and out of the door. WERE THEY CRAZY?! I was a project coordinator in an office-sized cubicle, and they were going to make me a receptionist??!! I would become the new receptionist while the current receptionist with less years of experience and no degree was promoted to some type of big assistant to the director. FOH! I'm out. My boss was insulted that I was insulted. She thought I would jump at the offer. I told her that she expected the little black girl to be so excited to keep her good paying, great benefits job that I would be happy and take whatever they offered me. HELL NO! Give me my package and I'm out. I planned to use that time to make my banquet hall ownership dream a reality.

In November 1999, Occasions Banquet & Catering Hall was born, and my life was reset. Everything was different. I had a new business with no salary, no benefits, and no employees, and I was married with two small

children. I had to become a master juggler. While even the best jugglers occasionally drop balls, my children were NOT going to miss a step. On that, I put everything.

I questioned whether I had made the right choice. Not of leaving my corporate job, but for not just getting another job elsewhere. I've had many days where I've regretted my choice. That sentence was for those who believe that once you quit that dreadful job and open your own business, you will automatically live happily ever after. Owning your own business is a constant challenge. It takes hard work and endless sleepless nights. If you're lucky and good, you will continuously grow and develop your business and the hard times and challenges will become fewer.

Before leaving corporate America, I spent months researching the catering hall business. I tried diligently to speak with current hall owners to learn more, but no one would help me. I had to come up with creative ways to get information from them. Breaching the code of silence was impossible.

I went to banks to find out what I would need to obtain a loan. I got a loan officer who advised me to contact the Service Corps of Retired Executives (SCORE) which is a national non-profit organization that counsels aspiring entrepreneurs and works with them to develop their business plan. I then had to find a space for the hall. Once I completed my business plan, I took it to my loan officer who admired it and told me I definitely qualified for a loan. BUT, I had to find a space first and the plan

had to be updated each time I found a possible space with all the numbers based on that particular space.

Finding a space was a challenge of its own. Each Sunday, I would buy the paper and search the classifieds for buildings. Real estate agents for many of those commercial buildings were Jewish. Based on their religious or personal beliefs, they did not shake my hand upon meeting me and they would not freely talk business to me. I had to take my male contractor friend with me to building viewings. The agents would not take me on as a regular customer, which meant they would not call me when they got spaces that might interest me, so I had to spend every Sunday researching the classifieds then calling agents on Monday mornings about the buildings listed. Many times, they were the same agents I had met with the week prior.

After a year, I finally found an agent who showed me a building that I loved but could not afford. The property was an abandoned warehouse that required lots of costly dismantling before any rebuilding could begin. But as fate would have it, the company that bought the building was only using a small area and renting out the rest. Unlike the other agents, this one called me and asked if I wanted the space. The rest is history.

Now I had a space; a signed, 10-year lease; architects; and contractors. I was ready to go. I updated my numbers on my business plan and skipped to my loan officer. Wouldn't you know it, I was not able to secure a loan. Turns out the experience I had coordinating events and my corporate experience was not considered enough

to run my own business. A minor (MAJOR) detail that was conveniently omitted from all of the prior meetings I had with that loan officer.

Determined not to be defeated before I even got started and in the absence of loans or grants, I pulled equity out of my home, drained my bank accounts, and borrowed from my family to convert the abandoned warehouse into a 17,000 square foot, three ballroom banquet hall. My landlord gave me two months to make my renovations before rent was due. In my rush, I was dropping money constantly. My project manager/architect used most of my money, unbeknownst to me, to fund his own project. That project went belly-up, so just that quickly, I lost over $30,000 and he disappeared. Dream deferred. I asked my landlord if I could get rid of one floor of the hall. I was advised that they would put it back on the market, but since I'd signed a 10-year lease, I would have to pay the rent until it was re-rented. That could take one month or several years. There was no way to control it.

All of those scrapes managed to bring out the diamond in me. I worked in the office of a friend's daycare business in the morning then opened the office of the hall in the afternoon and stayed through the evening. My children spent many nights with me at the hall. My aunts forced all of my teenage cousins to work for me, or rather with me because I only paid them $20. The plus was that they were the first set of workers I developed and pushed so that they could become forces in their work lives.

Speaking with my younger self, I would probably, at first, consider discouraging myself from going into this business. I might tell myself all about the difficulties I had and weigh my financial beginnings with where I am presently. I would take a good look at what I did and how I did it and maybe consider going a different route. Possibly investing my money differently. Especially seeing what COVID-19 is doing to my business and all of my savings and gains. Then, I would take a good look at what I have accomplished being here these last 20 years and how it has put me in a position to help and work with so many people that I probably would not have been able to work with or help. Namely, the young men and women that, through my business, I guided, taught, and mentored. It put me in a position to, like my first two bosses, polish the emerging diamonds of some extraordinary young people. Many of these young men and women have become "bosses" in their own rights and they often return to give back to one of the people that they credit with their successes . . . ME. Wow, what an honor.

Owning Occasions allows me, hell, it forces me to be creative on so many levels. I get to create beautiful weddings and events and I have to be creative with pivoting and growing my business. I also get to work with community leaders to support the communities that support me.

With that in mind, I would tell younger me what I am telling you. Being an entrepreneur is not for the faint of heart. I've found that in being an entrepreneur, what

you know is important but like most businesses, WHO you know is very important. Networking is a must. I'm not good at networking and I hate networking events. I operated on my own and even though I saw successes, I believe I would have seen much more had I gotten to know more heavy hitters. That's a change I am making now. Make sure that if you are the smartest person in the room, you find another room. Always seek out people who know more than you.

No established catering halls would guide me when I was getting started. But I wouldn't let that stop me. I did all of my learning as I went. You have easier access through Google and the internet. Mentors may be easier to find. Search them out and teach those coming behind you. That's how we all grow.

Build a good team. Being a one man island is exhausting. But know that coveting and envy are human nature so stay alert.

Do not hire people and assume that they will do their jobs well just because that is what you need. Unless they have proven themselves, stay on top of them. Owning a business is hard for women, and even harder for black women. Men contractors tend to try to take advantage. Make sure they get it done right. If you have to, be "That B****."

As I look back, being an entrepreneur has its difficulties, but it definitely has its rewards. In these tough times, you have to have your own even if it's on the side. When you're ready, research, commit, build your team, and GET GOING.

CONFIDENCE SHOULD NEVER BE UNDERESTIMATED
Dr. Althea Hicks, EdD, MPH

~~~~~~~~~~~~~~~~~~~~~~~~~~~~~~~~~~~~~~~~~~~~~~~~~~~~~~~~~~~~~~~~~~

The values of faith, humility, and hard work were instilled in Althea since birth, so it was no surprise that higher education became a part of her lifelong journey. The New York City public school system was a rite of passage she experienced as an exceptionally gifted student. Life's lessons have driven her to success. She has close to twenty years of experience in research and program management. She currently manages grants and programs for Jonas Nursing and Veterans Healthcare at Columbia University. Althea holds a doctorate degree in education from St. John's University, a master's in public health degree from City University of New York-Hunter College, and a bachelor of science degree from Temple University. If she could speak to her younger self, she would encourage herself to have confidence in her abilities, never underestimate her talents, and believe in the impossible.

To connect, email her at altheahicks@gmail.com

~~~~~~~~~~~~~~~~~~~~~~~~~~~~~~~~~~~~~~~~~~~~~~~~~~~~~~~~~~~~~~~~~~

Raised in a Christian, African American family, church on Sundays and family reunions were the norm. As a college sophomore, I became a member of Sigma Gamma Rho Sorority, Inc. and I have remained active to

the point where I am now a ruby member. I have truly been blessed with the love of family, the advantage of education, and a strong support system. Family, friends, teachers, and employers have always encouraged me to excel above and beyond the average. I have pursued certain goals and opportunities in my life and there were also times when opportunities were presented to me.

Yet, there were so many times I questioned how I would be able to succeed. Would I be able to keep up with the competition? Was I truly qualified for the level of success they saw in me but I did not see in myself? Those questions went through my mind; however, I am happy to say that by God's grace, I have made it to where I am today.

If I were given the opportunity to speak to my younger self, I would speak to that young lady around the age of 25. That is the age I always wish I could have remained forever. I would sit her down and say, "Hey, A! Please listen to me. Now, I know you want to live a little and enjoy your life, but I need you to look closer at your future and what you want that to look like so that you can start working on it NOW!" There are so many pieces of advice I could include here, but I think my number one piece of advice would be to build your confidence. That has played a major role in where I am today. And although I have accomplished many things, I believe I am still destined to do so much more. Someone once said, "There is so much talent in the grave." I truly believe that is a fact and I can only hope and pray that I do not let my talents end up in the grave.

When it comes to mastering goals, I realize that time is a priceless commodity. It is something that you can never get back. I would encourage my younger self to really consider the future and acknowledge that it is closer than it seems. Although 10 or 20 years can seem like a long time from now, it is so easy to get caught up in the daily tasks and entertainment of life that you don't realize how fast the time is going by. You do not have to wait for someone to endorse your goals or dreams, you just need to have faith and take the right actions toward making them happen. Focus on what you need to do to accomplish your dreams so that when the opportunity presents itself, you can take advantage of it.

I was always very shy and quiet around people, including family, friends, and people I grew to know very well. I always questioned what to say and wondered if I should say what was on my mind. As a young woman, I began to expand my network of peers and colleagues, and I met people from many different ethnicities and walks of life. It was then that I learned more about the struggle of women in other religions and countries who were silenced for their beliefs and opinions. It was also at that time that I began to experience missed opportunities because I did not speak up and express myself. Eventually, I began to speak more and take advantage of voicing my opinions. I realized that if I said something about a matter, if it came back to me, at least they could not say that I did not say anything.

Therefore, I would tell my younger self to build your confidence. By letting your voice be heard, you never

know how others will respond. Having confidence will allow you to take more risks without fearing other people's opinions. I remember when I decided to pursue my doctorate degree, I shared the decision with my significant other at the time. Instead of getting the support and excitement that I expected, I received the response: "Why did you do that without me?" Although I continued to pursue my journey, much time had passed before I realized I had to take the journey alone. I had to have the faith and confidence in my abilities to accomplish that goal.

Many years ago, when I became a supervisor, we had to attend one of those two-day personality assessment trainings. That was my first time participating in a training of that nature, so it was an opportunity to not only learn something new about myself, but it allowed me to learn something new about my colleagues. During that training, I learned about some of my personality traits that were identified in the assessment and confirmed by my colleagues. It was an eye-opening experience that helped me move forward in my professional career because I was more informed about my strengths and weaknesses.

The personality assessment found me to be fact-based and data-driven. It determined that I tend to search for information and make decisions based upon analyzing facts. That was familiar to me because I was always aware of my thought process in making decisions. I usually weighed facts and potential outcomes, but once I made the decision, I found myself confident

in my choice. After learning that about myself, I took time to evaluate how I view and make decisions in other areas of my life. I realized that that skill also transferred to my personal life, even today. Over the years, this has helped me build confidence in my decision-making. I have learned how to conduct assessments based on facts and data and how to make decisions for improvement both professionally and personally.

I have certainly developed other professional skills along the way that have contributed to my development and success. If you have never taken a personality assessment training, I would encourage you to do so. I am sure you may learn some new things about yourself that will help you move forward in achieving your goals. You may already be familiar with your strengths and weaknesses, but you may learn that you have traits that others see in you that you may not see in yourself. You may also learn some new things about others that may help you in your interactions with them so that you can accomplish your goals in life.

As I considered starting the doctoral program, I asked myself, *How do you plan to accomplish this goal? How will this impact your future?* One thing I have always been taught is the power of prayer and having faith in God. I have kept this as a staple in my life. I have learned that God's faithfulness has always been constant. There were times when I did not have the money or the resources, but I always had faith that God would provide for me.

I look back at when I was working on my doctorate and realize I could have done a better job at projecting a timeline for my goals and accomplishments. Once I committed to the doctoral degree program, I had a general timeline of the program goals and projected milestones; however, I did not prepare my personal timeline so that I could use my time wisely and effectively to complete the program. In other words, I could have done a better job at time management. From the day I committed to earning a doctoral degree, I never thought that I would encounter four doctoral programs before I completed my degree. It was not until I began to meticulously work on my time management that I began achieving success in that endeavor. I am grateful for that lesson because it has shown me how to break my goals down into smaller tasks to reach my milestones and gain overall success.

I also asked myself how my decisions would have an impact on my future. I thought about my future career and eventually retirement. That was helpful because over the years I see how I have used my strengths to work with my colleagues and be effective in the marketplace. I also see how I have been able to use my skills to help others. I have worked with so many non-profit and community organizations. In addition, I have been able to identify opportunities for resolving conflict and negotiation by identifying the thought process of my colleagues.

Now, let me be real. I encountered my share of setbacks, moments of discouragement, and distractions and pitfalls. I had to make some sacrifices in the form of time spent with family and friends and missed events. I am

sure I even made some mistakes along the way. Through all of that, I have realized that it is interesting how we are always learning new things about how we operate and how we handle certain situations. My journey to this moment in my life has shown me that despite the challenges, it is possible for me to exceed my expectations. I have learned many things about myself, including the importance of having confidence in my ability to be successful. With the help of God, I look forward to using all of the things I have learned to help me accomplish even more.

As a young woman, there were a few moments that were key to how I think about success. One of them, which I already shared with you, was the moment when I was asked, "Why did you do that without me?" In that moment, I realized that I did not want to have to rely on someone else to achieve my goals. That moment fueled my confidence; I knew I could accomplish anything I set my mind to. Although I was not naïve to the fact that I still needed help in some cases, I realized how much I needed to utilize my own skills and talents to accomplish my goals.

Another pivotal moment for me was when I almost gave up on getting my doctorate degree. After having many setbacks, I finally reached the point where I realized that if it was God's will for me, He would allow it to happen. It was then that a door opened for me unexpectedly which changed my mindset. It not only increased my faith in God, but it also made me realize that things won't always come in the form we expect. It

made me consider being open to unconventional ways of achieving my goals.

I have overcome many obstacles in my life, from early on as a miracle baby to this day as an adult. One final moment that greatly impacted me was when I graduated with my degree. I realized the importance of persistence. It is important to keep seeking opportunities even when your prior attempts fail. Just like searching for a job or a home, you must find the right match. Have a level of confidence so strong that you are not afraid of the "No" and you are determined to find the "YES."

As previously mentioned, I grew up in a strong Christian family. The values of faith, prayer and Scriptures were a constant in my life. As a personal motto, I often live by the words of the Bible in Ecclesiastes 3:1: "To every thing there is a season, and a time to every purpose under the heaven." This Scripture has been helpful throughout my journey because it has given me encouragement and peace when faced with challenges. It has also provided confirmation for me when successful opportunities and endeavors have come.

Actionable steps that have helped me over the years are certainly networking and taking chances. I have been blessed to have contacts in my network that I have known since the inception of my career. I encourage maintaining positive connections because you never know how they may play a role in your life in the future. I was given a chance to work in my current position because of a former colleague from years ago. I have also learned the importance of taking chances. Although

there are no guarantees, sometimes taking a chance is the only way to the next step in your journey. The opportunity to enroll in my doctoral program came because I took a chance in pursuing this degree through a weekend program.

If I were helping a friend on a journey like what I described, I would encourage her to take some time to plan her journey out, use her time management skills, and evaluate her strengths and weaknesses to identify how she will achieve her goals. In addition, I would encourage her to recognize her talents and abilities and have faith in knowing that she can overcome any challenges. Also, she should stay persistent and focused so that distractions and life's demands do not deter her from accomplishing her goals. Lastly, she should remember the Bible verse in Ecclesiastes 3:1 and know that when it is time for her to embrace her success, at that moment, she will win!

Chapter Seventeen
CHARACTERISTICS OF A TRAILBLAZER
Darlene Williams

Darlene is an award-winning businesswoman and the founder of D. Aiken & Associates Worldwide, the pre-eminent personal and professional development coaching firm. The firm's professional imprint is: **The Higher Level Method**. The firm's success formula is: **Higher Level Thinking + Higher Level Performance = Higher Level Results. Period!**™

Distinguished by her allegiance to preeminence, Darlene coaches professionals on a wide array of personal and professional development concerns. She is also an international bestselling author, expert facilitator, event planner, and adjunct lecturer. Her work and the work of her clients have been seen on OWN, ABC, CBS, VisaNet (Peru), and in *National Geographic*, *ESPN* magazine, *Rolling Stone*, and more. Darlene holds a master's degree in human resources management as well as professional certificates in business and life coaching, and she is pursuing a rhetorician certificate from Harvard. She is a proud member of Delta Sigma Theta Sorority, Inc.

Learn more at www. daikenassociates.net

Remember when you were little and you would go outside to play? In competing with the other children, you were happy whenever you came in first place. Perhaps, if you are like most children, you made a big deal out

of being first, especially if it was not the norm for you. That small feat, which was so inflated at that time, might even be something that you and those friends talk about during your reunions. You also remember the fanfare that came with the actual event and how everyone seemed so thrilled. As a result, you may even have a childhood nickname because of that time you accomplished something that no one had ever done before. Remembering it always manages to place an enormous smile upon your face. What an extraordinary feeling!

Unfortunately, as an adult, coming in first may not always be such a joyous experience. This is particularly the case when you come to find that you are in the wrong company. As a trailblazer, it is incumbent upon you to recognize your position and embrace it with resolute confidence. There is very little room for external unhappiness, or trepidation becomes your best friend and causes you to second-guess your every move. As the years roll by, you may find yourself stifled because you are afraid to make a move which becomes the catalyst for stagnation. To effectively blaze any trail, one needs to be fearless. The Bible says in Philippians 4:6-7 (TLB): "Don't worry about anything; instead, pray about everything; tell God your needs, and don't forget to thank him for his answers. If you do this, you will experience God's peace, which is far more wonderful than the human mind can understand. His peace will keep your thoughts and your hearts quiet and at rest as you trust in Christ Jesus." While this is not always easy to do, by far, if you diligently work

at making this prayer an integral part of how you operate, you will not be disappointed.

Trailblazers must be willing to endure being isolated for long periods of time. Isolation is where you become impregnated with innovative ideas and aspirations that will assist with the development of your strategic plan. Expect to be ridiculed by family and friends as they, oftentimes, operate from the frozen perception perspective. Meaning, whatever manner they have become accustomed to associating you with is the manner in which, in their minds, you should continue to operate or something is not right with you and it is their job to consistently remind you of who you used to be. Since they usually will not understand the reason for your "changed behavior," nor their commitment to oppressing you, here is where you will be told all of the reasons why you are incapable of accomplishing your goal, why this idea is half-witted, how you are squandering your time, or how no one in your family has ever done "that." They will even bring your attention to the many casualties of those who endeavored this feat prior to you, and so on. Trailblazers must be willing to concede that not everyone is entitled to procure information with regard to their dreams and goals.

Trailblazers must become comfortable with being uncomfortable as they navigate unchartered territory. Ponder for a moment the amazing inventor Sarah Marshall Boone. According to Biography.com, Boone was the daughter of parents who were slaves. Think for a moment about the period of time in which she was living and what

her living conditions must have been like. Keep in mind that there were no such things as computers, internet, and social media. Consider the fact that it was illegal to know how to read as a black person. We will not even begin to discuss what the circumstances were like for women, especially black women. Can you imagine, for another moment, how her family must have felt when she announced that she wanted to invent an ironing board and there was cotton that needed to be picked, crops to harvest, areas in the house that needed to be cleaned, and meal preparation that needed to be tended to? All of that without the aid of a dishwasher, washing machine, blender, food processor, or store bought processed and pre-packaged food. Now here she comes with an idea! Imagine, for just another moment, the pushback she must have received from her family who, withal, loved her dearly.

Biography.com also indicates that Sarah was a dressmaker, and it is said that she needed her dresses to stand out from her contenders in an effort to attract a plethora of clientele. During her days, there was no such thing as an ironing board as we know it today. However, one would take a large plank, prop it up on two separated chairs, lay their clothes over it, and iron their garments. Sarah had the idea to invent an instrument that would permit for one side to be narrow so that sleeves and fitted materials would be able to be ironed too. With the plank, only large items could be ironed and smaller items remained wrinkled. She would also design the board to permit the clothes to be shifted without further wrinkling once ironed. Sarah added padding so that the wood

impressions from the plank would not appear on the garments. To assist with perfecting the board, she made it collapsible so that it could be stored with ease in small places. Sarah became a wife, birthed eight children, took care of her widowed mother, and went to school to learn how to read. She wrote a proposal that would eventually grant her a patent that would make her one of the first black women to accomplish such a thing.

Is this a black history lecture? Maybe, since I'm a lecturer. But the point that should not be missed is that we do not live a one-dimensional life. So, while life is occurring whether we are living to our fullest potential or not, trailblazers recognize the need to work on enhancing their lives and are cognizant of the fact that their work also enhances the lives of others. We all, to this day, benefit from the use of an ironing board. This is true even if we send our garments to the cleaners.

What trailblazers recognize is something that non-trailblazers do not—they are responsible for changing the ways of the world. Changes are made by trailblazers on a variety of levels. One is not necessarily more important than the other; however, all are very necessary. Trailblazers are selfless and interested in the greater good. They are unstoppable forces that view themselves as small necessary cogs that make the bigger wheel turn with ease. Trailblazers come to realize that they may not attain their goal after the first, second, third, or perhaps the fifteenth time, but failure and giving up are never options to be placed on the table for consideration. Trailblazers threaten that they will give up when they are extremely fatigued,

but they find themselves back at it again, after a moment of rest. Those who do give up are forgotten and do not make changes nor history. It does not mean they are not valid or an also-ran, it could mean that they were not destined to blaze that particular trail. Trailblazers recognize the need to be in tune with themselves on a regular basis in order to be effective with their balancing act.

Trailblazers possess a relentless drive for progress while wearing blinders. Loved ones may oftentimes view them as standoffish until they become aware of who they are involved with. Especially since they spend time in isolation due to working steadfastly as well as learning to discern who the naysayers are and then having to deal with them accordingly. This is not easy, by far, especially when many are family, relatives, and dear friends. Trailblazers learn to not accept being tolerated by anyone, as that is an insult. When people tolerate you, they are putting up with you because they have a hidden agenda that is usually destructive.

Trailblazers are constantly battling with knowing how to discern whether they are judging others or whether they are using keen discernment. This is extremely important to trailblazers because, keep in mind, as stated earlier, they work for the betterment of others.

Successful trailblazers should come to know: (1) that life really is fair because at some point, life is not fair to all of us, which makes it fair; (2) that everyone gets what they are able to negotiate, not necessarily what they deserve; (3) to not fear money; (4) to not talk down about money; (5) their worth; (6) to walk away, with confidence, from

situations and people who do not recognize or value their worth; (7) that the law of attraction is real; use it regularly; (8) that friends help us to remain sane or remain the same; know who is who and what section of the arena in our lives each belongs to; (9) that sometimes we are the problem, not others; we must learn how and when to check ourselves; (10) how to recognize patterns of behavior from feigned professionals who say they are vested in the higher level thinking process, but when it is time to commit to engage in the actual work, they become attitudinal, resistant, inert, and gross wasters of time; and (11) that God and gravity are real! We do not have to believe in either; however, both operate with or without permission, understanding, agreement, disagreement, etc. If we go against either, at some point, we will come to believe in their reality. Prayerfully, it will not be too late.

Oftentimes, we have been advised, perhaps by parents, guardians, or mentors, to navigate differently, only to refuse their correction. The concept of what you would tell your younger self is based on what we have come to know as a result of having not listened and wanting to map out our own way. The reality is our life is occurring in the manner in which we are supposed to be living it right now. We were meant to endure the trials and tribulations we have encountered as we were to be shaped into exactly who we are. Embrace that! Live an intentional life, without regret. Definitely make the best decisions possible, all the while realizing that with that, we will still make mistakes. If we are happy with who we are today, that is a blessing. If we are not, that too is a blessing. And

since you are reading this, such is an indication that you can make some changes and begin living the life befitting your dreams and goals. It is no one's fault, except our own, if our life is not what we want it to be. A successful life requires a substantial amount of work, strategy, sacrifice, effective networking, consistent education, and dedication. Do the work! Do not make excuses! Do not play the blame game! Become detached from people, places, and things that keep you adhered to negative and debilitating thoughts and actions.

Trailblazing is not for the faint of heart; thus, the rewards are great and granted to few. Trailblazers live a faith-based life. They know that faith has zero limits. Now that you know what some of the characteristics of a trailblazer are, what are you willing to do and when are you willing to get started?

THE HIGHER LEVEL METHOD ™
COACHING GUIDE

The Higher Level Method Success Formula:
Higher Level Thinking + Higher Level Performance =
Higher Level Results. Period! ™

STAGE ONE:
HIGHER LEVEL THINKING ™

You must think differently. How? By studying, learning, and researching. New information shifts your paradigm as it alters what you already knew. You must do the work. Studying, learning, and researching is different for each person. You may need to go back to school, or you may be the kind of person who can commit to reading different books or researching in a library or via scholarly pieces online, etc. Whatever it is, there is no way around doing the work.

STAGE TWO:
HIGHER LEVEL PERFORMANCE ™

Now that you have researched, gone back to school, or read books, scholarly pieces, etc., you must do the work. Just because you have soap in your bathroom does not mean you are clean. You must take it out of its packaging, get your wash cloth, get into the bathtub, run the water, rub the soap onto the wet cloth, produce a lather, and apply it to your body. You can only apply what you have actually learned. So, if you are having trouble applying

what you have read, researched, etc., that means you have probably not really learned it. You cannot advance to this stage without having completed the first stage.

STAGE THREE:
HIGHER LEVEL RESULTS ™

You will begin to see higher level results once you have fully completed the first two stages. Do you know the saying, "Who you know gets you into the room"? Well, what you know is what keeps you in the room. Once you've arrived, it is imperative that you can hold your own. This occurs once you've done the work. Doing the work builds knowledge. Knowledge builds confidence. Confidence attracts confidence—personally and professionally. Watch your life change once you work with our coaching firm.

The work is not easy! You will need assistance! It is doable! We'll show you how! Discover your higher level at www.daikenassociates.net.

Connect on Instagram
@thehigherlevelmethod

The Visionary Author

Darlene Williams

The Coauthors

Ashley Sides Johnson

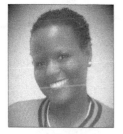

Fatima Y. Robinson

Taniella Jo Harrison, MBA

Charise Worthy

The Coauthors

Jennifer Thomas

Dr. Kayra Alvarado

Sheryl Walker

Jennifer Hallman-Almonor

Cassandra Hill

Regina Perry, MBA

Deidre Hudson

Krystal L. Bailey

Tameko Patterson, PMP

Latasha M. Smith

Michaela Renee Johnson

Dr. Althea Hicks, EdD, MPH